DAVID BALZER

CURATIONISM

HOW CURATING TOOK OVER
THE ART WORLD
AND EVERYTHING ELSE

COACH HOUSE BOOKS, TORONTO

first edition, third printing

Published with the generous assistance of the Canada Council for the Arts and the Ontario Arts Council. Coach House Books also gratefully acknowledges the support of the Government of Canada through the Canada Book Fund and the Government of Ontario through the Ontario Book Publishing Tax Credit.

LIBRARY AND ARCHIVES CANADA CATALOGUING IN PUBLICATION

Balzer, David, 1976-, author
 Curationism : how curating took over the art world and everything else / David Balzer.

(Exploded views)
ISBN 978-1-55245-299-8 (pbk.).

 1. Curatorship--History. 2. Art--History. I. Title.
II. Series: Exploded views

N410.B32 2014 708.009 C2014-904495-X

Curationism is available as an ebook: ISBN 978 1 77056 387 2.

For Nadja

Introduction

My research for this book began quickly and fortuitously. Carolyn Christov-Bakargiev was in town; I snagged an interview. Christov-Bakargiev was the artistic director of Documenta 13, the 2012 version of the contemporary-art event that takes place in the small town of Kassel, Germany, every five years. For decades, Documenta has set the pace for what is current in contemporary art. Christov-Bakargiev was of particular interest, for Documenta 13 was free-floating and amorphous, and she had refused to call her team of curators *curators*, instead using the term *agents*. Surely she would have something to say about the increasing use of the noun *curator* and the verb *to curate* outside the art world, where playlists, outfits, even hors d'oeuvres are now curated.

'That is a sociological question, not an art question,' she told me, irritated. The generalizations we were making were obvious, verging on meaningless. She pointed to Italian philosopher Paolo Virno's 2004 essay *A Grammar of the Multitude*, which, she claimed, 'says it all.'

Still, she furnished me with an exegesis. 'We now live in a society where everyone [fears] they're the same, so they want to specify and differentiate,' she said. 'My playlist is different from your playlist; my Facebook page is different from your Facebook page. It's a sense of anxiety, where you think you don't exist if you're not different from everybody else. You can't be part of the multitude. Whereas at the time of [Thomas] Hobbes, it was the opposite. You can't be part of the country, the community, the society, unless you become the same, because you are born different, specific, unique.

'Now we're all fucking the same. We have the same iPods, the same airports. And in order for the political system to work, everybody has to be driven by that drive [to be different]. If they don't do that, their energy will explode into a Third World War.

'I'm being polemic,' Christov-Bakargiev joked, finally. And she was, but she had lit a fire. I determined I did not want this book to focus on the popular understanding of curating as an expression of taste, sensibility and connoisseurship. This is not to say that I don't deal with these things, but rather that this book takes for granted a reader's understanding of the current *Oxford English Dictionary* definition of *to curate*, as an extension of museum and gallery practice, an act of selecting, organizing and presenting items in the vein of an arbiter-editor. (It should be noted that genetic labs also employ curators, who essentially do the same thing, with scientific data.) Instead of writing about taste, then, which would risk fetishizing the curator, I wanted to write clearly about *how* we got to this point. How did the curator ascend? How did the curator's practice bleed into popular – especially popular-consumerist – culture? The connection was, in my view, intimate and essential.

Hence *curationism* – a play on *creationism*, with its cultish fervour and its adherence to divine authorship and grand narratives. Curationism is also, of course, a poke at the contemporary art world and its pretentious, strained relationship with language (which Alix Rule and David Levine of the magazine *Triple Canopy* recently dubbed 'International Art English'). We now not only use *curate* as a verb, but also the adjective *curatorial* and the noun *curation*. Curationism also speaks to our general fixation, since the early-twentieth century, with isms, with camps and paradigms – our internet-age affiliations with them an extension of personal branding. (One of my heroes, Erykah Badu, called her first album *Baduizm*, suggesting the only ism to which she subscribes is her own complex, constantly evolving one.)

Curationism is, then, the acceleration of the curatorial impulse to become a dominant way of thinking and being. I contend that, since about the mid-1990s, we have been living

in the curationist moment, in which institutions and businesses rely on others, often variously credentialed experts, to cultivate and organize things in an expression-cum-assurance of value and an attempt to make affiliations with, and to court, various audiences and consumers. As these audiences and consumers, we are engaged as well, cultivating and organizing our identities duly, as we are prompted.

Hence the two sections of this book, 'Value,' in which a chronology of the curator is the primary focus, and 'Work,' in which the hyper-professionalization of the art world as well as our own shifting definitions of labour are addressed. Our obsession with the curator as an 'imparter of value' (a phrase I reiterate in the coming pages) has implications for everyone, inside the art world and out. Complicit in this matrix of value-making, we (often unwittingly) take on new personal and professional responsibilities. As Christov-Bakargiev said to me, in a comment clearly inspired by Virno, 'The curator is the most emblematic worker of the cognitive age.' This book is not anti–art world or anti-curator. It is strongly critical, but also merely an account, an acknowledgement, of curation's close alliance with capitalism and its cultures. As Tom Wolfe points out in *The Painted Word*, an admitted lodestar for *Curationism*, the art world has long been loath to admit its fundamental affiliations with, and origins within, the bourgeoisie, engendering, in Wolfe's view, a paranoid turn away from the object, which nonetheless (or, rather, inevitably) engenders various cults of objectification.

Like *The Painted Word*, this book is for a general, non–art world and non-academic audience. Despite the influence of Virno and others, it does not employ what has become known as critical theory. Academics will no doubt recognize affiliations with this or that theorist, with whom I may or may not be familiar. Critical theorists, who were and are essentially philosophers, are now often miscast as discrete thinkers, when in fact

many are expressionist ponderers, explicitly repudiating an authorial, proprietary view of ideas and their histories. Indeed, without their diction and personae, many critical theorists would seem to hold self-evident, even plainly unoriginal, thoughts. Lacan did not invent the use of the mirror as metaphor for formative semiotic development; neither did Freud, from whom Lacan borrowed the idea. Foucault was not the first to speak of punishment, madness, order and sexuality. Barthes espouses any number of obvious thoughts; it is the genius of his articulation that sets them apart. (Most students read these French writers in translation, confusing things further; it's akin to listening to Serge Gainsbourg in translation.)

This mismanagement of theory represents several problems that typify the curationist moment. Firstly, it subscribes to an avant-garde understanding of the generation of ideas – in which 'new' and 'original' are paramount and successive, like a string of dictators, each making their elders obsolete and rearranging their country. As I argue in this book, the value-imparting system of the avant-garde has reached its inevitable (and glorious!) terminus in the early twenty-first century, where an idea no longer has to be 'brand-new' or 'never-been-done-before' in order to be valid. On that note, I believe in deep learning and context, certainly, but excessive fretting over attribution and precedent is paralyzing to dynamic intellectual thought. Any idea can be original if the mind that expresses it is confident and cultivated enough. This is what I strive for. It need hardly be said that this book contains no footnotes.

A myopic devotion to critical theory secondly engages in a pattern of demystification and remystification that is a key, obfuscating modus of the curationist moment – a not-so-covert method to instate, canonize and brand. Curators have become expert at presenting exhibitions and biennials that appear radical and oppositional, whether to museum ortho-

doxy or to regimes, common behaviours and codes, when curators in fact employ such radicalism and opposition precisely to attract audiences and to increase their events' cultural capital. In the 1990s, underfunded museums recruited curators who in turn recruited artists devoted to audience engagement and seemingly unusual, participatory actions as a means of making the institution appear more enlightened and be more popular. These artists and curators are not outsiders; they have become some of the most successful, established cultural figures of our time. Similarly, the academy has used critical theory, in particular French poststructuralism, gender theory and queer theory, as a way of welcoming new students and diversifying (indeed revivifying) humanities departments. While an important political advance, such theory has become its own industry, merely trading an old canon for a new one, and retaining the same hierarchies and worshipful groupthink. There is little subversion to putting Judith Butler or Slavoj Žižek on a T-shirt, or to liking them on Facebook.

Is the curationist moment over? Not quite, nor, in many respects, will it ever be, as long as we continue to consume things, be particular and create culture – that is, be human. I deal with the specifics of this in the last chapter of this book, contending that we are moving on to something else, or at least could be. Katherine Connor Martin, Head of U.S. Dictionaries, Oxford University Press, who generously walked me through the provenance of the verb *to curate* (which has its roots in the early-1980s performance-art scene), thinks the word is very important. 'If you were going to choose your vocabulary developments in the aughts,' she says, 'this would be on my list of things that are really emblematic of what's happening in the language.'

That said, Martin notes, 'it's entirely possible that in, say, 2018, someone will look at [the use of *curate* as a verb] and

say, "Ugh, that's so dated, nobody says that anymore." But *The Oxford English Dictionary* includes lots of obsolete and dated terminology. It's an inventory of the entire history of English. So when we add something like [*curate* as a verb], we're saying, "Regardless of what happens in the future with this usage, it's important enough and well-tested enough now to be recorded for posterity." We generally like things to have history behind them, and when we saw this went back to 1982, [we deemed] three decades of usage good enough. We think of it as writing the biography of these words.'

Dear reader, the biography of the curator, the curated, the curatorial and curation – a story for our times.

Prologue
Who Is HUO?

Miami's South Beach is nothing like a white cube. On its easternmost side, along Collins Avenue and Ocean Drive, lies an impressive fleet of art deco hotels and, among them, the mansions of the resort neighbourhood's current and erstwhile residents, from J. C. Penney to Gianni Versace, who was shot dead on his front steps in 1997. Everywhere is colour, traffic; life is instinctive, vulgar, dangerous, fun. The cacophony of capitalism defines the area, from these hotels, to the clustered, modest houses and apartment buildings lying slightly west of them (many, in their lingering decay, redolent of South Beach's 1970s and 1980s depression – a period, with its cocaine dealers and crime, depicted in Brian de Palma's 1983 film *Scarface*), to busy Lincoln Road, one of the U.S.'s first pedestrian malls, and its surrounding, riotously colourful surf stores.

December is tastefully warm in South Beach. The sun toasts rather than scorches. Historically, this has not been a big tourist time, but over the past decade or so that's changed. I arrive in 2013 as a journalist, part of the hordes of mostly Europeans and Americans who have come to see Art Basel Miami Beach.

Art Basel typifies the ever-growing popularity of the fair in contemporary art, in which international commercial dealers converge in large cities at convention centres, piers, custombuilt tents and hotels, securing high-priced booths in which to display and sell work from their stables of artists. Founded in Basel, Switzerland, Art Basel chose Miami Beach as an outpost more than a decade ago because of the wealthy Miami collectors who frequented its flagship event. Since then, around two dozen fairs have cropped up alongside Art Basel Miami Beach, most within walking distance – to say nothing of the myriad of parties, pop-up shops and ribbon cuttings that have come to comprise what is now Miami Art Week. South Beach is not

transformed so much as intensified: more preening, more plastic surgery, more partying, more celebrities. Contemporary art seems put there by a production designer. Depending on how you see it, it's either the best or worst kind of ambient noise.

Much has been written about Art-Basel-as-Wasteland. In a 2012 Slate piece entitled 'The Eight Worst Things About the Art World,' fashion writer and Barneys New York 'creative ambassador' Simon Doonan put Art Basel at the top of his list, snidely describing it as 'overblown…[with] all that craven socializing and trendy posing.' There is a lot of art at Art Basel, to be sure, but what, implies Doonan, does it add up to? As if at a crowded, expensive party, works jockey noisily for attention, devoid of gravitas and thematic order. It is no museum or gallery, in other words. Curators, those trusted sybils of the contemporary art world, are conspicuously absent.

Or are they? Famously, advertisements for bars and events are towed by planes above South Beach's long, populous white-sand beach. I go swimming one day, looking up from the crashing waves to see a different banner: 'HANS ULRICH OBRIST HEAR US.' I laugh. It's such an obscure plea – a knowing combination of unctuousness and plaintiveness. Hans Ulrich Obrist is one of the world's top curators, and a few nights previous I had attended a panel discussion he had moderated between Kanye West and architect Jacques Herzog. (Obrist calls both, to varying degrees, friends.) Clearly, Obrist is here. But why?

The banner's culprit was Canadian artist Bill Burns. Over recent years, Burns has made drawings, postcards, sculptures, watercolours and digital mock-ups addressing a variety of art-world authorities. The works express (and parody) the desperation and vulnerability felt by contemporary artists when fathoming the internationally known directors, curators and collectors who could make or break them. One Burns work is a proposal to affix a large sign to the roof of London's Tate

Modern reading 'Hans Ulrich Obrist Priez Pour Nous' (in English, 'Hans Ulrich Obrist Pray For Us'). In Miami, Burns hired airplane banners every day to make similar appeals, not just to Obrist, but to other power or star curators, like Hou Hanru and Beatrix Ruf.

It's likely the beach crowd stared up in indifference at Burns' banners. Outside of Obrist, is Burns certain anyone he had appealed to by name was actually present at Art Basel? 'I have no clue,' he tells me. 'The fairs are very big events, but they take a certain kind of personality to enjoy, like going shopping at Christmas.' What would a curator do at Art Basel Miami Beach? 'It's true that curators over the last two hundred years have been understood as taking on a kind of public-service role. But now there's a curious mixed economy in the art world. A curator's job is often, at a fair, to cajole a collector into buying something for a museum – which I'm sure, for many, is not very pleasant. Artists, curators, collectors: we're all part of a regime. I'm part of it as well. You are too.'

After seeing Burns' banner, it occurred to me I was in eyeshot of the fuchsia tent of Untitled, one of Miami Art Week's newest fairs, whose press materials emphasized its use of a curator, Brooklyn's Omar Lopez-Chahoud. Lopez-Chahoud selected the galleries for Untitled, in some cases overseeing the arrangement of the fair's booths and works. But Untitled's gambit is not, in fact, novel. There's Frieze London, and now Frieze New York, both of which rigorously jury their exhibitors, using curators to handle 'special projects' such as sculpture parks on their tent grounds. And Frieze's template is arguably Art Basel's, whose former director, Samuel Keller, pushed curation to the forefront of the fair's brand (in Switzerland and in Miami), collaborating with Obrist as early as 2000 to launch, at first, a series of talks at the Swiss fair.

Now, within the sterile, chaotic confines of the Miami Beach Convention Center, there are, for instance, curated sections

for artist films and videos. Art Basel Miami Beach's Nova and Positions sectors, the former meant for gallerists to display new works and the latter for gallerists to showcase the work of a single artist, do not have apparent curators, but suggest a 'curatorial sensibility': things judiciously selected and sleekly arranged, granting the fairgoer an experience much closer to that of a gallery or museum. When one considers Burns' (correct) guess that curators also come to fairs to acquire art for their respective institutions (or, more frequently, to function as advisors for trustees and the like who hold those institutions' purse strings), the fair becomes not anathema to curators, but specifically tailored to them. They occupy – and when not occupying, compellingly inform – both of the fair's essential roles, those of buyer and arranger-facilitator.

If curation is everywhere, it is also both strangely embodied and disembodied. The curator is no longer just an art-world figure. Within the art world, a select number of curators like Hans Ulrich Obrist dominate their institutions but also transcend them, playing roles in media and culture. Outside the art world, curation is powerful but also diffuse. Celebrities act as curators not just for exhibitions, but for music festivals and boutiques. We 'curate' in relation to ourselves, using the term to refer to any number of things we do and consume on a daily basis. Curators are visible in so many likely and unlikely ways. Are we witnessing their ultimate triumph, or a troubling, fascinating moment of their undoing?

While it can be said of professionals from many fields, it is particularly true of curators that no two are exactly alike. There is certainly no one quite like Hans Ulrich Obrist, who is affectionately known in the art world by his monographic acronym, HUO. One could begin by citing his dependable inclusion in the art-world 'power lists' that have become so omnipresent over the past five years or so. In 2009 to 2013,

Obrist – with, in some years, his co-director at London's Serpentine Galleries, Julia Peyton-Jones – made the prestigious Top 10 of *ArtReview*'s Power 100 list every year, taking first place in 2009 and second in 2010 and 2012. While *ArtReview*'s Top 10 is sometimes broken by curators – Christov-Bakargiev was No. 1 in 2012 due to Documenta – it is more typically occupied by dealers, collectors and directors. If *ArtReview* is to be believed, Obrist is nearly as powerful as Larry Gagosian, the billionaire 'superdealer' with galleries in New York, L.A., London, Rome, Paris, Geneva and Hong Kong.

And while Obrist is not as wealthy as Gagosian, his influence, despite or indeed because of his singularity, is as representative. The *New Yorker*'s Nick Paumgarten described Gagosian as occupying 'an ecosystem of his own' – so does Obrist. As the world's most famous contemporary-art curator, Obrist sets a remarkable precedent, acting as the archetype for the professionalization and domination of his field.

Ubiquity and its attendant commitment to industry are Obrist's hallmarks. In May 2013, New York–based collector-oriented website Artspace put Obrist first in its '8 Super-Curators You Need to Know' piece, claiming he is renowned for 'being everywhere at once.' This trait is cited repeatedly by Obrist's friends and admirers. A profile of Obrist on the *New York Observer*'s Gallerist blog, also from May 2013, is titled 'Marathon Man,' with the kicker 'UBIQUITY.' Writer M. H. Miller makes the wild claim that, 'Over the course of a single cigarette, I once witnessed [Obrist] roll up to an art fair in a car, run inside, come back out murmuring to his companion about what impressed him, then get back in the car and head to the next event, like some kind of highbrow European Road-runner.' Modernist café-society photographer Brassaï timed his fly-on-the-wall exposures to the duration of a cigarette's burning; in the 2010s, the cigarette can be used to measure the frenetic pace of the internationally mobile curator.

Hans Ulrich Obrist was born in Zurich, Switzerland, in 1968 to non–art-world parents, yet his legend begins early. In an interview for the December 2013/January 2014 issue of *Surface*, of which he is the cover star, he speaks to Paul Holdengräber about formative experiences. Obrist, who has a celebrated memory, was struck by the vast Abbey library of Saint Gall at the ripe age of three. He came across a Giacometti sculpture at Zurich's Kunsthaus shortly thereafter, and vowed to 'go to museums every day.' By the early 1980s, the pioneering curator Harald Szeemann was at Kunsthaus Zurich, and Obrist, now a teenager, soaked up his influential programming, visiting his Der Hang zum Gesamtkunstwerk group show forty-one times. (Obrist remembers this 'because [he] counted it.') By sixteen, Obrist claims to have visited all the museums in Switzerland. By seventeen, he had cold-called Swiss art duo Fischli/Weiss and asked to visit their studio. They got on, and this precipitated more artist visits: Christian Boltanski in Paris at age eighteen; Gilbert & George and Gerhard Richter in London soon after. This was the genesis of Obrist's reputation for hyper-travel, the youth-discounted InterRail Pass getting him across Europe. 'I was everywhere, all the time, but I had yet to produce anything,' he tells Ingo Niermann in his 2011 book, *Everything You Always Wanted to Know About Curating But Were Afraid to Ask*. 'Those were apprenticeship and journeyman years, a European Grand Tour.' In 1991, at twenty-three, Obrist curated his first group show in his kitchen, featuring Fischli/Weiss, Boltanski and other names that were or were to become art-world royalty.

Having already formed important mentorship relationships with curators Kaspar König, currently director of Cologne's Museum Ludwig, and Suzanne Pagé, currently artistic director of the Louis Vuitton Foundation for Creation, Obrist began Migrateurs, a curatorial project for the Musée d'Art Moderne de la Ville de Paris (MAMVP) under the supervision of Pagé,

who was director at the time. In *Surface*, Samuel Keller recalls his first, mid-1990s meetings with Obrist: '[He was] a pale, young, tall man schlepping around a large bag, with lots of documents, usually catalogues, always running around at a very fast pace… Whenever I showed up somewhere, Hans Ulrich was often already there – but only for 24 hours.'

It was around this time, 1993, that Obrist began to identify officially as a curator, his CV subsequently becoming a litany of exhibitions, biennials, publications and sundry appearances and accomplishments. Obrist worked at the MAMVP as a salaried, capital-C curator from 2000 to 2006. He took his current position at London's Serpentine Gallery, with the title Co-director of Exhibitions and Programmes and Director of International Projects, in 2006. This arguably marks the beginning of his bona fide international celebrity. A *Blouin ArtInfo* piece from 2008 calls him 'as close to a rock star as a curator can be,' attributing 150 international exhibitions to him since 1991.

Nineteen ninety-three was not only the year Obrist officially embraced *curator* but also when he officially began to record interviews, a medium in which he has become a sort of guru. At the time of the publication of his second volume of interviews in 2010, Obrist was purportedly in possession of two thousand hours of taped interviews with various artists, architects, filmmakers, scientists, historians, etc., all organized by the interviewee's last name. In that book alone, Obrist interviewed subjects as diverse as Björk, Doris Lessing and Alejandro Jodorowsky. In *Surface*, editor Karen Marta calls his interviews his 'divine passion' and likens them to poems. Obrist describes them as his retreat, his 'secret garden.'

Despite that avowal, Obrist's interviewing constitutes a colossal, very public aspect of his work. His impressive bibliography is in large part made up of ongoing transcripts of these interviews: in addition to two collected volumes, there is a series of smaller monographic artist-interview books (an

extension of his Art Basel Conversations series), of which there are, to date, more than twenty; *A Brief History of Curating* and *A Brief History of New Music*, compendiums of interviews with important curators and composers; *Everything You Always Wanted to Know About Curating But Were Afraid to Ask*, an interview-based advice manual and professional biography. To wit, all of Obrist's published interviews could fill a sizable shelf.

In 2006, Obrist's first year at the Serpentine Galleries, he began his Marathon series, the inaugural version taking place around a pavilion designed with Rem Koolhaas (every year, Obrist and Peyton-Jones commission a different artist-designed pavilion on the grounds of the gallery). This first version, twenty-four hours in length, consisted of non-stop interviews with dozens of cultural figures – David Bailey, Damien Hirst and Ken Loach among them. Obrist continues to host different sorts of Marathons on a yearly basis. In 2013, the topic was his 89plus project, co-conceived with curator Simon Castets, which highlights young artists born after 1989. Essentially, the Marathons are symposia or salons (a historical concept that greatly fascinates him) running without adjournment, the absurdity or effortfulness of this durational aspect making it performance art as well as a meeting of minds. True to Obrist's obsessive-compulsive nature, all Marathons are recorded and transcribed.

Obrist's commitment to the interview and to the general proliferation of work is reminiscent of Andy Warhol. But Warhol, the Pittsburgh-raised child of working-class parents from Czechoslovakia, created his Factory in Manhattan as a paradoxical mirroring and parody of the American industrial system. At the cheekily named studio, Warhol instigated a number of different projects. His screen tests mimicked the assembly-line star-making process of major Hollywood studios; his early films, boring by design, extended the screen tests to

depict extempore scenarios and, with his eight-hour film *Empire* (1964), a single slowed-down static shot of the Empire State Building, simultaneously celebrate the quotidian modern and deride the Hollywood epic. As Camille Paglia points out in her study *Glittering Images*, Warhol's famous silkscreens, which allowed him to turn out artworks at a breakneck pace, used 'a commercial process for fabric design… Disdaining authorship, he often used a rubber stamp to sign his paintings, and he professed indifference to their fate; they were as disposable as any other product of American manufacturing, then geared to planned obsolescence.' Warhol was lucrative, but his professed attitude toward his work was a characteristic lassitude. He was both self-propagating and self-negating; poet and critic Tan Lin notes in the fall 2001 issue of *Cabinet*, 'Eye and mouth are both surrogate modes of "being oneself"' and 'Warhol's two favorite surrogates were his tape-recorder and his camera.' Warhol, the ultimate postmodernist, turned himself into a machine in a kind of nihilistic denial of authenticity and authorship. His artistry was the sellout, his success at the cost of the essential him, whatever that was.

Obrist does this as well, but oddly, as a successor of Warhol, he is much more ingenuous. On examination, he seems the anti- or bizarro Warhol. In 2012, *New York* magazine noted his complete lack of ennui: 'He's not over anything, even as he's always on to the next thing.' Like Warhol, Obrist privileges self-negation, but it is of a remarkably different sort. 'I learned everything from artists,' he says, and his interview subjects reliably testify to this self-effacing sensitivity and curiosity. ('Curating always follows art, not the other way around – that would be awful.') Samuel Keller calls him 'the artist's best friend'; Klaus Biesenbach, director of the Museum of Modern Art's PS1 and curator-at-large at MoMA, calls him an 'idea machine.' Like Warhol, Obrist has a fascination with memory, but not in the sense of letting it be absorbed or displaced by

the mechanics and gadgetry around him. Obrist's commitment to memory is old-fashioned. To all his interviewees, to all the artists with whom he works, he offers, as the speaker of Shakespeare's Sonnet 55 humbly yet lavishly offers his lover, 'The living record of your memory. / 'Gainst death, and all oblivious enmity.' Obrist calls his ongoing process of recording and preserving interviews 'a text-machine' ('PhD students transcribe them into various languages'), but the end goal, unlike that of Warhol, a ditzy hoarder obsessed with trash, is rigorous, possessive archivalism. Obrist's productivity sets the gears of Warhol's Factory in reverse. His aim is to preserve. And so rather than the post-war American industrialists, Obrist's implicit model, while related, is earlier: the American Puritans and their proverbial work ethic. The title of one of his books, *dontstopdontstopdontstopdontstop*, is like a Dadaist take on a Puritan homily (e.g., 'Idle hands are the devil's playthings'). The title of his celebrated exhibition series, Do It, also recalls a homily. Ongoing since 1993 (that year, again), Do It is a series of instructions for exhibitions written by famous people Obrist has encountered. Its emphasis on didactic or pedagogical text as the basis for action, however whimsical, also suggests the Puritans, known for their devotion to scripture or 'the Word.'

Obrist's fraught relationship with sleep is also puritanical. Warhol's 1963 film *Sleep* provides the ideal counterpoint; this five-hour-long work, a precursor to *Empire*, depicts poet John Giorno sleeping. That's it. In this anti-film, sleep is the anti-subject: an oblivion suggesting death, a fixation of Warhol's. His camera stare once more demonstrates his nihilism, his celebration of inactivity. Giorno is idle, and Warhol, though aspiring to a static take, was forced, due to technical limitations, to work with a wind-up camera and to employ a rather complex edit. In this way, both Warhol and his audience become captive witnesses to absence, with the film becoming a loving, accidentally busy paean to inactivity, thwarting

traditional American values of industry. Incidentally, Giorno, according to legend, was the only one Warhol knew at the time who slept at length, given the prevalence of then-trendy 'uppers' among Warhol's circle.

Obrist, while Swiss, is more American. Ironically for a Swiss, he has an antagonistic relationship with the clock, and time (because there is never enough of it) – and thus with sleep. 'Sleep to me is like an accident,' he says to Ingo Niermann in *Everything You Always Wanted to Know About Curating But Were Afraid to Ask*, 'because I really don't want to sleep, and yet sleep outwits me again and again.' In several interviews, Obrist has reiterated his life's struggle with the body's need for rest. This again can be dated to the early 1990s, when his career takes off. An ongoing commitment to travel is one method Obrist uses to defeat the clock. As *W* editor-in-chief Stefano Tonchi notes, he is always in a different time zone, and so is 'in his own time zone somehow. There is no way to say where he is, because he doesn't have a time zone.'

In his war with sleep, Obrist looked at cultural precedent. French novelist Honoré de Balzac legendarily drank cup upon cup of coffee every day to sustain his productivity, and so the young Obrist tried to emulate him. 'I was having fifty coffees a day,' he tells Niermann. '[But] at some point it simply abated.' (Niermann notes that Balzac may have died from his coffee addiction, and Obrist laments that the novelist was '[r]elatively young' and it was a 'sad way to go.') After Balzac, Obrist adopted a variation of 'the da Vinci rhythm,' modelled after the Renaissance artist: he slept fifty minutes every three hours. This was successful (he claims his first books were written this way), but in 2006, after getting his job at the Serpentine, which requires regular office hours, he stopped it. Presently, as he relates in a video on the website Nowness in January 2014, he always gets up very early and never goes to bed after midnight. On starting his Serpentine position, Obrist

co-founded the Brutally Early Club, a crack-of-dawn salon that counts as one of its members another art-world worka-holic, performance artist Marina Abramović.

Like Abramović, Obrist's commitment to non-stop work and as little sleep as possible not only has its puritanical aspect but also an association with American celebrity. Obrist's Nowness video, *Morning Ritual*, shows the curator in a blue windbreaker taking his morning run through a sun-dappled, gauzily shot Hyde Park, where the Serpentine Galleries are located, while his voice-over relates the oft-told story of his lifelong attempt to conquer sleep. The accompanying blurb extols his industry, quoting him as saying the park is his 'extended office' and claiming he still finds time to read at least a book a day (in the video, he says, 'I cannot live without buying a book every day'). The video is unmistakable lifestyle porn: a stylized and sanitized fantasy version of what we could do or be, couched in consumerist compulsions and giving us pleasure precisely because we know such ideals are out of reach. Ex-model Martha Stewart is the reigning queen of lifestyle porn, but it has a rich tradition in American celebrity, from Old Hollywood how-to memoirs, such as Joan Crawford's *My Way of Life* (1971), full of sadomasochistic advice like 'Never let your husband see you exercise,' to blogs like Gwyneth Paltrow's GOOP, now frequently mocked for its ridiculous accounts of the star's virtuous domestic and professional lives. A typical GOOP sign-off: '11:29 pm now, exhausted and ready to do it all again tomorrow!'

In 2013, Obrist released a book entitled *Think Like Clouds*, a collection of his doodles that suggests that even when he's not consciously working, he's working. Designed by artist and publisher Paul Chan, the cover underlines Obrist's ubiquity, with digitized versions of the curator's head proliferated in a polka-dot pattern. Inside are more than two hundred pages of Obrist's scribblings, amassed from about fifteen years of

activity. In his introduction, Chan notes that, as is typical of doodling, Obrist will scribble during his interviews, or before and during public speaking, which makes him nervous. (Chan calls this 'a form of public notation.') The paper Obrist uses is telling: printed-out e-mails, conference itineraries, hotel stationery – all testaments to a frenetic, incessant, global pace. In a postscript essay, Michael Diers writes that Obrist's 'scribbles are attractive, and ask to be *looked* at as well as read,' positioning them as potential artworks. Yet he also rightly notes that, more and more, doodling is 'a feature of creative training programs for managers.' The entire book is uncannily reminiscent of the output of corporate-friendly doodling authority Sunni Brown, who has written two books on the subject and has held many international seminars. On her website, she calls her followers 'Doodle Revolutionaries' who 'put the DO in Doodle.' Always professing to be an inspiration rather than an impervious paragon, Obrist has, like Brown, gotten other people to follow his example. His popular Instagram account consists of shots of Post-it notes and other scribbled scraps from various cultural figures.

In 2010, Abramović appeared in a video, produced and directed by Klaus Biesenbach, to mark the release of Obrist's second volume of interviews. In this video portrait of Obrist, she begins by holding up a sign reading,

THE CURATOR IS PRESENT
THE ARTIST IS ABSENT.

She wears the clear-plastic-frame glasses that are Obrist's trademark, as if to suggest that, for the duration of this video, she is he, or he has somehow possessed her. She proceeds to tell us slowly that 'Hans Ulrich is…fast…sleepless…restless…curious…encyclopedic…adventurous…obsessed… possessed…art…Olympic…monotone…runner…volcanic…

hurricanic…mind-blowing…surprising…limitless…art-loving
…overmedicated…[et cetera]' and then repeats the list faster
and faster until it becomes gibberish. She may be teasing
Obrist, who by all accounts is a friend, or giving direct voice to
many artists' concerns about the phenomenon of star curators
like Obrist. If the curator is present, is the artist necessarily
absent, i.e., disempowered and negated?

More important, however, is the alliance. It's as if Obrist
is the other half to Abramović's binary, a Dostoyevskian
double. Much can be made of this. Both Abramović and Obrist
come from marginalized yet relatively new fields (performance
art and conceptual curating, respectively). Both seem to have
turned themselves into caricatured art-world celebrities,
whose defining feature is constant activity for the sake of
legitimizing their respective fields. On her part, Abramović
has in recent years been dedicating herself to her own
'Method' of performance art, to be taught through a bricks-
and-mortar Institute in Hudson, New York, but also at various
temporary satellite locations around the world. There is a
paranoia of professionalism here: a hyper- or accelerated
desire to make ephemeral creative practice into 'value' and
'work' in order to secure its status and canonization. For both
Abramović and Obrist, this dedication to permanence has a
mock-totalitarian/-dystopian cast. Abramović's Institute is
clinical and bureaucratic, its employees outfitted in white lab
coats; Obrist has co-founded the Agency of Unrealized Proj-
ects, an archive of unrealized ideas and arguably a play on
the National Security Agency, whose aim is also data collec-
tion. (Obrist counts Julian Assange among his many interview
subjects.) The danger, as writer Thomas Micchelli noted in a
2012 piece for the art blog HyperAllergic, is that imperma-
nence, in being so aggressively combatted, may paradoxically
be summoned. Either that, or a severe neutering takes place.
'[Abramović] refuses to accept…finality,' writes Micchelli, 'and

proposes to recycle a fleeting mode of experience, however ersatz, into infinity.'

As a curator, Obrist has seemed both a totalizing example of contemporary art and an anomaly, his ambition causing him always to have one foot out the door. 'I flirted with leaving the art world as early as the mid-1990s, perhaps for architecture,' he tells Niermann. 'It was all too constrictive; but as [artist] Carsten Höller once said to me: it is the least bad place. And that's how these bridges across disciplines came into being. I curate art; I curate science, architecture, urbanism.'

Obrist may be the most powerful curator in the world, but he could also represent the discipline's end-game: *après lui, le déluge*. As with Abramović, his attempts at securing his own – as well as existing, complementary – legacies, what he calls 'the protest against forgetting,' could constitute an elaborate sarcophagus, of which only pale imitations can later exist. As the typification of the curationist moment, Obrist may be its natural harbinger. To quote artist Philippe Parreno, 'I think [Hans Ulrich Obrist]'s one of the only great curators today – or the last one.'

We can't know who organized the first art exhibition. It is even more difficult to propose a teleology of curating, as it has become popularly known: any arrangement or editing of things, usually cultural. Arranging and editing, like sex and appetite, are common yet variously expressed. They are part of who we are and always have been. Mid-twentieth-century generalists spoke of this frequently. The great British art writer Kenneth Clark called collecting 'a biological function, not unrelated to our physical appetites' (think natural *selection*).

Sociologists, anthropologists and ethnologists contemporaneous with Clark, who looked for structural patterns across cultures, argued something similar. In his 1962 study *La Pensée sauvage*, French ethnologist Claude Lévi-Strauss advanced a complex view of culture creation stressing the fine-art term *bricolage*, a concept not unlike what we currently understand as curating. (A present-day florist in Austin, Texas, is named Bricolage Curated Florals.) Patrick Wilcken, in *Claude Lévi-Strauss: The Poet in the Laboratory*, elucidates Lévi-Strauss's theory of bricolage: 'Rummaging around their environment, [pre-literate societies] observed, experimented, categorised and theorised, using a kind of free-form science. They combined and recombined natural materials into cultural artefacts – myths, rituals, social systems – like artists improvising with the odds and ends lying around their studio.' The Lévi-Straussian *bricoleur* is, in Wilcken's estimation, 'a tinkerer, an improviser working with what was to hand, cobbling together solutions to both practical and aesthetic problems. *La pensée sauvage* – free-flowing thought – was a kind of cognitive *bricolage* that strived for both intellectual and aesthetic satisfaction.' The *bricoleur* is anyone attempting to plan, solve or create.

In his essay 'The Bias of the World,' art writer David Levi Strauss (no relation to Claude), formerly professor at one of the world's pre-eminent curatorial-studies programs at Bard College in Hudson, New York, also acknowledges the curator as *bricoleur*. But he begins his examination of the curator by looking at the titular origin of the word, a revealing exercise illuminating the contemporary curator's conflicted, paradoxical role. The use of *curator* can be traced back to the Roman Empire, in which *curatores* were bureaucrats made responsible for various departments pertaining to public works. (*Curatores viarum*, for instance, were responsible for overseeing roads.) The root of the word is the Latin *cura*, meaning *care*; *curatore* means, essentially, caretaker. The title of curator was used not just for bureaucrats, but for types of guardians or tutors under Roman law, who were either appointed to minors or to those with whom they were entering into contracts, in order to secure both parties from subsequent litigation due to the minor's inexperience. Curators could also be named as care-takers-cum-advisors for those classified as *prodigus*, or prodigal (i.e., proven to be squandering their estate or inheritance), and as lunatics. One should also not neglect the Roman *procu*-rator, most often a member of the equestrian class, and appointed to supervise outlying provinces. Pontius Pilate, the man who sentenced Christ to die on the cross, is referred to in the Bible as a procurator, although in other literature he is given the title of prefect.

By the Middle Ages, the Christian Church had appropriated the term. Writer Erin Kissane notes that *The Oxford English Dictionary* dates the term via William Langland's fourteenth-century poem *Piers Plowman*: 'curatoures' are parish priests, 'called to knowe [know] and to hele [heal]' their 'parisshiens [parishioners].' David Levi Strauss rightly deduces that the early roles of curators thus constitute this Roman-medieval double duty, a 'curious mixture of bureaucrat and priest,' a

split between 'law' and 'faith' – not unlike the contemporary curator within major art institutions, who, we assume, wants to make the public believe in art and artists, and also to function successfully within the political machinery of the museum or gallery, liaising with directors, donors and trustees, and sometimes securing works for loan or purchase.

There are pejorative suggestions to add to Levi Strauss's interpretation. The Roman curator, and especially procurator, was an agent – some might argue a tool – of the state. A person of rank, the curator was nonetheless at the mercy of those above him. Pontius Pilate is the obvious example of the toadying Roman procurator, sent to a far-flung colony (in his case, Judea) to enforce the power of his superiors. In the Gospels, Pilate is reluctant to condemn Christ. Depending on which source you consult, Pilate's decision to crucify Christ was due either to pressure from the Jewish Sanhedrin, who claimed Christ was controverting Jewish law, or, as the Sanhedrin themselves argued to strengthen their case, to Christ's flouting of Roman tax laws. In this latter sense, the Roman procurator Pilate is little more than a glorified tax collector. One could gather that the procurator is superfluous, only a nominal 'caretaker.' In *The Lives of the Twelve Caesars*, Roman historian Suetonius refers to procurators a few times, always with the implication that their titles are politic stepping stones. Of the Emperor Vespasian's greed, Suetonius writes, 'he advanced all the most rapacious amongst the procurators to higher offices, with the view of squeezing them after they had acquired great wealth. He was commonly said "to have used them as sponges," because it was his practice, as we may say, to wet them when dry, and squeeze them when wet.'

The medieval curate is a position that endures in the Church in varied form to this day. The curate's title is not as tokenist or honorific as the Roman curator's or procurator's could be; the curate has important duties within the hierarchy of the clergy –

he is what we commonly know as the parish priest. Said figure is responsible for the 'cure of souls,' a concept rooted in Pope Gregory I's sixth-century treatise *Liber Regulae Pastoralis*, commonly translated in English as *Pastoral Care*, which outlines the role of the clergy and defines 'cure of souls' as the exercising of the priest's duty within his assigned district. Contemporary curators, whose roles and responsibilities can often be murky or splintered, may find it amusing that the curate or parish priest was also expected to do a host of tasks, from delivering sermons to tending to the sick. The etymology of the term, and the meaning of the Latin *cura*, can be brought to bear here. According to *The Oxford English Dictionary*, *cura* had three main senses, 'care, concern, and responsibility'; 'cure of souls' is deceptive, then, because the curate or parish priest does not actually cure souls, per se, but care for them. The *Oxford* notes that it was only in late Middle English that *cure* develops its medical sense of healing. To care is not necessarily to cure, the former suggesting tending, the latter a more powerful ability to transform.

The stereotype of the curate or parish priest has long been one of a humble, hard-working, impecunious and at times obsequious man. The saying 'curate's egg' comes from an 1895 cartoon by George du Maurier entitled 'True Humility' in the satirical British magazine *Punch*. A curate, young, thin and hunched, sits in a restaurant with a bishop, his superior, who tells him he has been served a bad egg. The curate responds, 'Oh, no, my Lord, I assure you that parts of it are excellent!' Du Maurier's anxious-to-please curate may tickle disgruntled contemporary curators who feel pressure to answer to directors, trustees and artists, and to assure them that risky or contentious collections and exhibitions are indeed excellent. The curator is someone who insists on value, and who makes it, whether or not it actually exists.

And so it is that the two early understandings of *curator* that David Levi Strauss identifies – the Roman and the

medieval-clerical – suggest dependence and responsiveness rather than direct action and agency. This makes a lot of sense when we begin to think about the curator within the context of the museum or collection, an identity that starts to take shape around the sixteenth century. The curator cares for objects, and the objects, not the curator, are the focus. The history of the curator can, in fact, be seen as one of successive subservience: to institutions, objects, artists, audiences, markets. The phenomenon of the autonomous curator, which arguably began its brief tenure in the 1960s in tandem with the conceptual art movement, is thus a fleeting, strange, paradoxical thing. Even Obrist – his fame, industriousness and caricatured public persona a professionalized, effortful embellishment of that 1960s curator – depends on others to do what he does. In striving to give himself value and power, the curator doth, perhaps, protest too much. No curator is an island.

That said, the curator as we know her emerges with a twist of autonomy, through the vital concept of connoisseurship: a display of taste or expertise that lends stylized independence to the act of caring for and assembling. Early in its existence, 'curator' was arguably a grab-bag title, but nonetheless, according to writer Anthony Gardner, gained, after the Renaissance, a 'scholastic and artistic dimension.' Robert Hooke, a rival of Sir Isaac Newton's in Restoration England and Curator of Experiments for London's Royal Society, provides a fascinating example. Hooke, who among other things pioneered microscopic imaging, was, as Royal Society curator, responsible for putting on weekly demonstrations of material from the Society's Repository: a trove of specimens that, according to Sean Riley Silver, 'was driven by a grand institutional goal, an attempt to realize the ideal academic society imagined by Francis Bacon.' Ideally, the Repository was to have 'one of everything' (this Platonic notion of the comprehensive collection plagued early museums, which were

notoriously overstuffed, often with copies or fakes of unattainable objects). Hooke's demonstrations, which put him in the role of intermediary between the private, thing-filled Repository and the public audience of the Society, were theatrical 'experiments' showing and explaining its many wonders. Hooke the curator was both dependent and independent. His brilliant mind, as Curator of Experiments, was on display, but limited to what the contents of the Repository could evince. His experiments were in service of the Society, meant to heighten its value and that of the Repository's objects. Silver notes that some accounts suggest the excessive time Hooke spent in the Repository ruined his health, an example of the early-Enlightenment scholar whose entire being was given over to objects and their intellectual significance.

The Royal Society's Repository will sound familiar to students of art history, who will recognize it as an example of the Cabinet of Curiosities or the German *Kunstkammer* or *Wunderkammer*. These are the main Western precursors to museums, their creator-custodians precursors to contemporary curators, eclectic mixes of amateur and professional, committed both to connoisseurship and to care of objects. (*Curious* and *curator* both have that same Latin root, *cura*; *care* in Latin connotes both custodianship and taking an interest in something.) Cabinets were rooms, typically belonging to royalty, aristocrats and wealthy merchants, which, like the Royal Society's Repository, contained sundry objects of importance, from religious to geological. In many respects the cabinets were endemic of their time, which saw a fervent interest in colonial exploration as well as humanist-scientific research, and thus the desire to house and catalogue the objects of such endeavours. Some curators of the cabinets were also their owners, while some were hired by their owners. The cabinet of Irish physician and Royal Society secretary Hans Sloane, which contained a vast array of antiquities and natural-history

objects, was bequeathed to the state and became the foundation for the British Museum. Many cabinet curators had a busy, idiosyncratic flamboyance in which contemporary curators like Obrist find their precedent. Athanasius Kircher, for example, a German Jesuit priest and intellectual eccentric of the seventeeth century, was a proponent of the magic lantern, an early form of cinema, and advised famous sculptor and architect Gian Lorenzo Bernini on the construction of the Fountain of the Four Rivers in Rome, perhaps the first example of an artist-curator collaboration.

The Cabinet of Curiosities might look like an early period of freedom for the curator, although there was a marked subservience to objects and the person who owned them, reflected in the exclusive nature of the cabinets, which were not commonly open to the public. Nevertheless, the curator was positioned importantly within the cabinet, which for many owners was microcosmic, a mini-Eden over which they held exclusive domain, with their curator as a kind of Adam. The multidisciplinary quality of Renaissance and early-Enlightenment scholarship is also appealing to the contemporary curatorial mind, with the Cabinet of Curiosities becoming a renewed fixation in the mixed-media, grab-bag contemporary art world. (To say nothing of the internet, digital *Wunderkammer* extraordinaire.) A 2008 group exhibition at the MoMA in New York was called Wunderkammer and included such artists as Louise Bourgeois and Odilon Redon; *Cabinet*, an art magazine that has been around since 2000, seems directly inspired by the *Wunderkammer*, its mission statement to 'encourage a new culture of curiosity.'

The Cabinet of Curiosity might also be allied with the concept of the readymade, still so popular in current artistic practices, and forged in the early twentieth century by Marcel Duchamp with his exhibition of mundane industrial objects, including shovels and, famously, an upturned urinal. (Duchamp

would also *Wunderkammer* himself with a series of *boîtes-en-valise*, portable suitcaselike museums containing his own work.) Yet the presentation of objects as a creative and formal act, one conscious of onlookers, would not define the emergent museum of the eighteenth and nineteenth centuries, which, like the Cabinets of Curiosity, was cluttered and not terribly accessible. Instead, it would be up to those like Duchamp – preceding and successive cohorts of avant-garde artists, from the late-nineteenth to the mid-twentieth centuries – to modernize concepts of both exhibition and curation.

By most accounts, the curator of the eighteenth- and nineteenth-century museum was not much of a free agent. The late Edward F. Fry, associate curator at the Solomon R. Guggenheim Museum in New York in the late 1960s and early 1970s, has described the nascent museum curator as a tool of the state, as many museum collections, notably that of the Louvre in Paris, developed because of political turmoil and imperialism. Like the Cabinet of Curiosities, the Louvre, opened in 1793, was inescapably symbolic, a literal piece of the body politic. Early in its existence, after the French Revolution, it became the flashpoint for the didactic aims of the emerging Republic, and later, with Napoleon, morphed into a propagandistic 'universal museum' housing spoils of war. Its emperor-appointed curator, the ex-pornographer Dominique Vivant Denon, presided, in the words of scholar and gallerist Karsten Schubert, 'over the greatest museum collection that ever was' (however thieved). Denon was unquestionably charismatic, yet his overarching task was to catalogue and care for this booty.

Shortly after Waterloo, the British adopted a similar model with the British Museum. Exhibition halls were chronologically ordered but unlabelled and cluttered. In Schubert's words, 'the curator simply envisaged visitors in his own image.' This image was not dynamic, but pedantic, conservative and

bureaucratic; the curator was akin to a librarian or academic. 'The museums presented their political masters as custodians of world culture,' writes Schubert. 'In effect, the museum became the handmaiden of imperialism.'

At the same time, around the mid-nineteenth century, the salon reached its height. Salons and their ilk, including universal expositions and the annual exhibition of London's Royal Academy, are early examples of the selection-based exhibitions that are now standard in the art world. Popularly attended, presided over by a jury and thoroughly academic – in deliberate reaction to the commercial art market, which was also developing healthily at the time – the annual or biannual Paris Salon originally exhibited only members of the state-sanctioned Académie royale de peinture et de sculpture, but, after the revolution, opened up to non-members. In the mid-nineteenth century, the Paris Salon moved from the Louvre to the Palais de l'Industrie on the Champs-Élysées, a trade-showlike venue presaging the locales of today's art fairs. By the mid-nineteenth century, the Salon no longer turned up its nose at commercialism. Its catalogue, for instance, published contact information for artists so that buyers could get in touch.

The artist rebellion against the Salon is legendary and has been duly romanticized by art history. The story goes that the Salon was a stifling force against which the most innovative artists of the day fought, but this is misleading. The Salon juries were inconsistent, accepting some artists some years and rejecting them in others. Wholesale rejection of artists now known to us as important was rare, and market autonomy was as vital to the rebelling artists as aesthetic autonomy. In 1855, for instance, Gustave Courbet set up an out-of-pocket Pavilion of Realism near the Salon because, even though the jury had selected ten of his paintings, his *The Artist's Studio* was deemed too large. (In a 2014 *Mousse* magazine supplement about artist-curators, curator and writer Elena Filipovic

described this move as 'an entrepreneurial one-man show.') Eighteen sixty-three was pivotal, the year of the first Salon des Refusés, a.k.a. Exposition des Ouvrages non Admis. This was an exhibition at the opposite end of the juried show in the Palais de l'Industrie, one in which artists who had been rejected by that year's capricious jurists, who had only admitted 30 percent of applicants, were given the chance to show. Napoleon III was the instigator, perhaps the curator: in a provision befitting a ruler in a fairy tale, he offered artists a chance to exhibit so the public could judge their worth. Many refused the Refusés – to be shown there was, after all, the art-career equivalent of being pilloried or stocked – but proto-modernists like James McNeill Whistler and Édouard Manet did not. Famously, Manet's groundbreaking painting *Le déjeuner sur l'herbe* was one of the pieces in the Salon des Refusés.

After the Salon des Refusés, artist-initiated exhibitions began to proliferate. There is no nominal curator here – artists themselves curate, a brave move for the time, complementing a newly personal, direct, collaborative and sometimes raw approach to making work, and in opposition to the academy-, studio- and patron-bound practices that had become standard. Paris exhibitions held by the Impressionists in the 1870s and 1880s, such as by the collective Societé Anonyme, ran concurrently with the Salon; the first, in 1874, was held at the studio of the photographer Nadar. The exhibitions might be seen as the forerunners of what we now call artist-run culture, but they were not divorced from the market. The emergent dealer played a role. Crucially, the Societé Anonyme, following the Royal Academy (and vociferous individuals like Courbet), rejected the Salon practice of 'skying' works: hanging paintings in a busy constellation on walls, with works deemed less important receiving obscure placement. Instead, the works were organized in two clean rows, standing out better and thereby easier both to appreciate and to sell. The exhibitions of the

Societé Anonyme would continue to be held in intimate houses or studios in the manner of current-day auction previews, and would set the stage for other artist groups who forged alternative markets and patron systems for themselves, such as turn-of-the-century artist group the Nabis, also Paris-based, who circulated among a group of wealthy Jewish intellectuals who exhibited them in their drawing rooms and offices.

The tactics of late-nineteenth- and early-twentieth-century artists in exhibiting work to emphasize value, both ideological and commercial, cannot be divorced from the concept of the avant-garde. The term, coming from the military meaning of *vanguard* (the preliminary segment of an advancing army), was likely first used in conjunction with art in 1910, by the right-wing London newspaper the *Daily Telegraph*. As art historian Paul Wood notes, 1910 was also the year artist-critic Roger Fry, another progenitor of the contemporary curator, held his controversial post-Impressionist show in London featuring Gauguin, Seurat and others. These and other exhibitions were called 'avant-garde,' but not, Wood writes, in a good way, especially not in turn-of-the-century England, when French politics and art still 'connoted insurrection and instability.'

However, it is newness that truly characterizes any avant-garde expression, infatuating both left and right in the modern era, from industrialists to artists. Imagist poet Ezra Pound's famous slogan was 'Make it new,' and a popular understanding of *avant-garde* as difficult or experimental might mistakenly elide this crucial aspect of the term. (One can certainly think of difficult or experimental works that are not terribly shocking, or necessarily new.) And so new, while by nature challenging, can also connote improvement, refinement and innovation. In this way, exhibitions initiated by artists, including overhauls in exhibition design begun by the Impressionists, sought to improve, refine and innovate public and collector understanding of what art was and could be as concept and commodity.

The desire was above all to privilege art for art's sake, indeed often to redefine it. Heckling or confounding the establishment was secondary, for some a distant aim. And so it was that the avant-garde's commitment to newness was about enhancing an artwork's worth on all levels, including commercial, and most of all about granting formal and conceptual value. This is very close to what we now understand as an essential curatorial task. As anyone who has gone to a contemporary museum or gallery will attest, if an object is on a plinth, hanging from a white wall or placed in a Plexiglas vitrine, we are much more likely to see it in new ways and to contemplate it as art.

Unsurprisingly then, many avant-garde artist shows of the early twentieth century were openly opposed to museums as they had come to be known in the nineteenth century: dusty, fusty, musty jumbles of obscure, status-quo objects that were priceless yet unlabelled, kept away from audiences and from new, modern understandings of art's progress and worth. The swaggering, bumptious Italian futurists, who embodied a particularly contrarian aspect of the avant-garde, loathed museums. In their manifesto of 1909, F. T. Marinetti compares museums to cemeteries. (The futurists' iconoclasm soon became allied with the Fascist sensibilities of Benito Mussolini, a political avant-gardist par excellence.) While seemingly jejune, the futurists' denigration of museums alongside their championing of new, potentially violent technology like the automobile, which Marinetti describes as 'more beautiful than the Victory of Samothrace [the popularly known *Winged Victory* in the Louvre],' was a salient provocation to art institutions of the day. If museums wanted to be relevant, they had to become like the automobile. They had to become exciting. They had, somehow, to become avant-garde. It was the young practices of industrial and interior design – avant-garde disciplines obsessed with newness, and also inherent to curation – that would help museums do exactly this.

It is a lovely irony for those interested in the development of modern institutional curation that, twenty-five years after the Futurist Manifesto, in 1936, MoMA's inaugural director and curator, Alfred H. Barr, Jr., would put a plaster cast of *Winged Victory* next to futurist sculptor Umberto Boccioni's *Unique Forms of Continuity in Space*, for the exhibition Cubism and Abstract Art. The gesture, by the pioneer of institutional curating, resonates multiply. Firstly, it acts as a wry comment on the eighteenth- and nineteenth-century curatorial practice of having tacky plaster replicas fill holes in collections, which often privileged Greco-Roman statuary. (This can still be seen in kitschy abundance at London's Victoria and Albert Museum.) More than this, the action epitomized Barr's triumphant assimilation of the avant-garde, something many avant-garde artists thought impossible. In a comment now considered apocryphal, but that is nonetheless relevant, Gertrude Stein reacted to the opening of the Museum of Modern Art by quipping, 'you can be a museum, or you can be modern, but you can't be both.' Barr proved this wrong, building the MoMA in lockstep with avant-garde ideas.

Socially and in photographs, Barr seemed an improbable spokesperson for the avant-garde. The son of a Presbyterian minister and eventual scholar at both Princeton and Harvard, he became well-connected to art historians and philanthropists while still quite young. In 1929, at age twenty-seven, Barr was appointed director of the new MoMA by Paul J. Sachs, related to the Goldman Sachs banking dynasty, who approved him along with a committee that included MoMA founder Abby Rockefeller, wife of John D., and A. Conger Goodyear. Barr became recognized for his shrewd ability to organize and connect. He was extremely fond of the pioneering German art school the Bauhaus, which he visited shortly before his MoMA appointment, and was, accordingly, friends with architects, from the Bauhaus's Walter Gropius to American Philip

Johnson, co-founder of the popular mid-century International Style that was inspired by the philosophy of the Bauhaus, and a man soon to be intimately involved with MoMA's programming. Barr's flow chart connecting all of the modernist avantgarde's various isms with sobriety and clean fluidity is famous, suggesting his mind behaved like a museum. An iconic photograph of Barr from 1967 shows him in front of Alexander Calder's 1936 sculpture *Gibraltar*. By then greying and balding, Barr stands in a long coat next to the sculpture, which is a humble, abstract interpretation of the eponymous rock, as if next to a mirror. Poignant and cute, the photograph suggests Barr's fierce determination, his pride for his accomplishments eclipsed by his earnest admiration for the art for which he so tirelessly advocated.

As Mary Anne Staniszewski suggests so brilliantly in her seminal study of MoMA, *The Power of Display*, Barr not only minted contemporary exhibition design, including the notion of the white cube, but also the idea of the contemporary curator who is crucially informed by everything artists do. In borrowing heavily from Europe, collaborating with – and indeed pinching ideas from – artists, favouring group shows and mingling works of art from different time periods and cultures to illustrate influence and theme, Barr proved the museum could be as thrilling as the futurists' fetishized automobile. He also proved that the museum could be both a machine and a temple to machines, influencing their display, even their manufacture. In 1951, in fact, MoMA, under the aegis of Johnson, opened Eight Automobiles, an exhibition of cars.

Alfred H. Barr, Jr., was galvanized by artists but did not fancy himself one, unlike some of the curators who would come after him. Similar to heads of Old Hollywood production studios, Barr imported ideas and people from Europe and Russia: the clean, white, minimalist display styles of turn-of-

the-century Berlin museum director-curator Wilhelm von Bode, and those of burgeoning European artist houses; the geometric latticework exhibition design of Russian constructivist El Lissitzky; Bauhaus methodology, including lecture programs, labels and explanations for works (architect Mies van der Rohe, one-time Bauhaus director, was a key collaborator with Barr). Like those Hollywood producers, Barr always aggregated and assimilated European ideas, never leaving them quite as they were, but creating a very American concoction.

The ability to impart value was of utmost importance. MoMA's mission was to articulate the modern across disciplines, regions, even time. Barr's favouring of minimalism in exhibition – his signature was exhibiting paintings symmetrically, in one neat, eye-level horizontal line, against walls covered in light beige monk's cloth – lent everything a formalist air. Staniszewski writes convincingly of the concurrent development of retail displays, and of the mutual influence American retailers and MoMA had on each other. The department store of the nineteenth century was, Staniszweski writes, as jumbled and as busy as the museum of the same era. Barr's Useful Objects shows, for instance, beginning in the late 1930s, displayed reasonably priced consumer goods as exemplars of sophisticated, accessible industrial design. Placed in the context of Barr's and his colleagues' streamlined, sleek spaces, anything looked valuable, meaningful and modern. In this sense, Duchamp may have invented the readymade, but it was Barr who most expertly appropriated it and understood its allure.

Barr was to remain the template for the institutional curator-director until the 1960s, an era that, as we will shortly see, marked the prolific embrace of the avant-garde and, in tandem, of the independent curator, the subject of increasing romantic fixation. In 1959, MoMA's New American Painting show – featuring abstract expressionists such as Jackson Pollock and Mark Rothko – went on an overseas tour, an

ultimate assertion of Barr's imperialist wresting of the modernist project from Europe. It is now no secret that abstract expressionism was covertly promoted by the Central Intelligence Agency as a Cold War cultural counterattack. (By the 1950s, art in Russia had devolved into state-sanctioned Socialist realism, a far cry from the modernist experimentation of the 1910s, making American abstract expressionism look like a metonym for freedom and opportunity.) It is worth mentioning as well that, in the press release for the touring show, Elizabeth Bliss Parkinson, MoMA's President of International Council, noted, 'The show was organized in response to repeated requests from institutions in Europe.' The exhibition, influenced in every sense by artists' innovations, was now a commodity, the curator-director a proven importer-exporter, following the rules of supply and demand.

Before the proliferation of curators, there was the proliferation of artists. This truly began in the 1960s and 1970s, when the avant-garde underwent a dizzying acceleration, largely due to the post-war economy in the West and the associated maturation of the baby boomers, who embraced bohemianism and experimentation en masse in unprecedented ways. Postpainterly abstraction, colour field painting, op art, pop art, action art, performance art, earth art, video art: a Seussian litany of art movements arose, and, if it existed, a Barrian flow chart depicting them would look pretty hairy. By 1975, such movements were ridiculed by Tom Wolfe in *The Painted Word*, which acknowledged that, yes, the early twentieth century had its own string of funny-sounding isms ('Fauvism, Futurism, Cubism, Expressionism, Orphism, Suprematism, Vorticism'), but they all 'shared the same premise,' that is, formalism or art-for-art's-sake. In contrast, the movements of the 1960s and 1970s saw a wilful fracturing, generally favouring what is now known as conceptualism. Wolfe describes, with flamboyant

dismay, the apparent abhorrence of the object in these movements, in which idea (concept) trumps object (form). Wolfe's *The Painted Word* could be a response to what is now understood as a major critical text of the conceptualist moment, an anthology published in 1973, two years before Wolfe's essay: *Six Years: The Dematerialization of the Art Object from 1966 to 1972*. Consisting of highlights of conceptualist work, it was edited and annotated by one of the first curators in the contemporary mode, Lucy Lippard.

Dematerialized art, or conceptualism, is the putative opposite of modernist-formalist fetishism, a reaction against what Barr did with MoMA. The modernist avant-garde ended, unexpectedly to many, in the heightened institutionalization and commodification of the artwork. But the avant-garde continued to search for new ideas and, superficially, radical ones. It follows that the next, novel project of avant-garde art would be, after the object itself was exhausted, this dematerialization: taking away the object's objecthood to get at the edgy essence of creativity and ideas, and to prevent art from being consumed and packaged by the bourgeoisie.

This strange, rhetorical and arguably illogical movement of art away from the object, effected by the bourgeoisie itself and thus in many senses an absurdist project straight out of Swift, was understandably interpreted in different ways. Some wanted to put a complete stop to the class-, leisure- and diversion-based idea of art that had existed since the Renaissance, creating, as Carl Andre did with a line of hay bales in Vermont, works that 'are going to break down and gradually disappear…[that] never [enter] the property state.' Eva Hesse, Mel Bochner and others, in related acts of dematerialization, interpreted objects loosely, constructing them of ephemeral, deprecated and/or natural media. Some wanted to revive the non-tangible and even spiritual ideas of the creative act. Yoko Ono's popular book *Grapefruit*, like Lucy Lippard's contemporaneous series of

exhibitions based on directions for artist projects written on index cards (instruction art was then a trend), contained poetic directions that made dematerialization seem not terrible but beautiful, the instructions themselves constituting an exquisite poem: 'Light canvas or any finished painting with a cigarette at any time for any length of time. See the smoke movement. The painting ends when the whole canvas or painting is gone.'

It was during this concentrated questioning of both art institutions and what they housed that, ironically, curators, those sedulous figures historically intrinsic to these things, underwent a reinvention. They became both prominent and, eventually, romantic. In this crucial moment, the curator's custodial or caretaking position becomes supplanted by that of the connoisseur; or, rather, custodianship *becomes* connoisseurship. Curators no longer tended ground, but secured, organized and landscaped it. This emerged out of a real need: in the 1960s and 1970s, the art world increasingly yearned for a figure to make sense of things, to act as advocate for an ever more obtuse, factionalist art scene. Too many artists, too many movements, too many works in too many shows, too much discussion: who would parse them? The curator's new position entailed duties of ringleader, translator, mediator, diplomat, gatekeeper. It was a full-time job, and a completely new one.

It is not, however, as simple as to say that the curator made a swift ascent, especially not professionally. In the wake of conceptualism, a variety of non-exhibition, non-artist entities ascended. They would, come the 1990s, coalesce into the curator's role, birthing the curationist moment. Until then, the critic, fine-art publishing and the dealer would also play crucial roles in parsing and elaborating on the art world's bewildering commitment to dematerialization. These would also, unsurprisingly, be roles taken up by artists themselves, who, in this period of incipient multidisciplinarianism, were eager to try on new hats, appropriate art-world machinery and confuse

fixed notions of who was supposed to do what. Early contemporary curators were not quite outliers, but they were variously groomed in different fields. (There were certainly no curatorial-studies programs back then.) Jean Leering, director of Eindhoven's Stedelijk Van Abbemuseum from 1964 to 1973, was trained as an architectural engineer; important California curator Walter Hopps, described by Obrist as a 'mercurial iconoclast,' began as a booker of jazz musicians; Seth Siegelaub, extraordinary proponent of conceptualism in New York, started out as a plumber, and when he quit the art world in 1972, went on to do more traditional curatorial work, cataloguing and founding a research centre devoted to textiles.

Then there is Harald Szeemann – probably the most discussed and romanticized curator of the era. Well-known present-day curator Jens Hoffmann calls him 'the father of modern curating – or creative curating, if you will.' Szeemann began in the theatre, as a set designer and actor. Another present-day curator, Daniel Birnbaum, in his *Artforum* eulogy for Szeemann in 2005, humorously describes Szeemann's last theatrical endeavour as an 'egomaniacal one-man production of *Urfaust* in 1956 (yes, Szeemann played all the roles himself).' This controlling nature of Szeemann's, usually toward creative ends, explains both his mythology and controversy. Preferring to describe himself as an *Ausstellungsmacher* (exhibition-maker) rather than a curator – an apt nomenclature update that unfortunately never quite caught on – Szeemann would turn the curator, in Birnbaum's words, into 'a kind of artist himself...a meta-artist, utopian thinker, or even shaman.' Physically, he resembled more of an artist than Barr's gentlemanly museum director, with his characteristic full beard, tousled hair and loose, partially unbuttoned collared shirts.

Szeemann made his name at the Kunsthalle Bern in Switzerland, which suggests art institutions were not completely hostile to the interventions of these new curators or

exhibition-makers. (The *kunsthalle* is a type of non-collecting, artist-centred European institution usually supported by government funding and often run in part by artists; the *kunsthalle*'s dedication to the display of avant-garde and contemporary art, and its attendant bureaucratization in the form of publications, symposia, outreach, fundraisers, etc., is reflected in most major museums today.) Live in Your Head: When Attitudes Become Form (1969) was Szeemann's break-through show and is now canonized and much-discussed in the contemporary art world. What Szeemann did was not unique: several shows like Attitudes, in which conceptual art was handled conceptually, transforming the space in which it was exhibited, were happening internationally around the same time. But in concert with his ongoing project to turn Kunsthalle Bern into a kind of lab or artist's studio, and with what came after, particularly his co-curatorship of Documenta 5 in 1972, Attitudes remains a landmark exhibition. Soon-to-be-famous European conceptualists such as Joseph Beuys were included in the show, as well as members of the New York scene, including Walter De Maria, Fred Sandback and others.

One could talk endlessly about Attitudes, and the contemporary art world has: its reputation versus its actualities, its problems versus its triumphs. Ultimately, to discuss it opens up the tensions and triumphs that would come to surround the contemporary curator. As a microcosm, it is a remarkably predictive event. For one, the show, along with other conceptualist exhibitions mounted by Lippard, Siegelaub, Hopps and others, again demonstrates how the curator was a culling figure: in a way the herder, even the alchemist, of a self-dispersing scene. (The notion of the curator as alchemist persists strongly into the curationist moment; in 2007, critic Jerry Saltz published an article about the 52nd Venice Biennale called 'The Alchemy of Curating.') In his study *The Culture of*

Curating and the Curating of Culture(s), Paul O'Neill discusses how shows like Attitudes asked artists to respond to the exhibition space. Rather than Barr and his MoMA, which treated all objects with the same kind of sleek uniformity (plinths, vitrines, horizontal eye-level hangs), Attitudes, or at least its utopian hope, made artists intervene spatially. Some work in the show: Lawrence Weiner chipped away a square in the plaster on a wall; Michael Heizer smashed the concrete on the sidewalk in front of the building; Alain Jacquet exposed its wiring system. The renegade avant-garde interpretation of such 'actions' is that they, in the terminology of Siegelaub, 'demystified' the conditions of exhibition, deconstructing the gallery or museum space.

But the curator proves this is not quite the case. As an agent of these acts, both in the sense of being a representative, but, more powerfully, of being a catalyst, the curator is still centralizing, magnetic. Szeemann's connection to process-as-spectacle, which he got from his theatre background, stylistically united artists who seemed opposed to the very notion of style.

When Attitudes Become Form was sponsored by cigarette manufacturer Philip Morris. To call this informative, which many in the contemporary art world do, may act as its own form of demystification. But to think of it solely in this way is facile. First, one must acknowledge that it was during this time that more corporate sponsorships and partnerships emerged to buoy conceptualism. Calling Szeemann a sellout, then, and seeing an acknowledgment of the Philip Morris sponsorship as a mere exposure of the corporate bones that prop up the art world, is not that illuminating. One finds more complex significance, a fascinating overlap in motivation between curator and sponsor, in the exhibition catalogue for When Attitudes Become Form. A short introductory note from John A. Murphy, president of Philip Morris Europe,

emphasizes the connections between avant-garde practice and the business world:

> The works assembled for this exhibit have been grouped by many observers of the art scene under the heading 'new art.' We at Philip Morris feel it is appropriate that we participate in bringing these works to the attention of the public, for there is a key element in this 'new art' which has its counterpart in the business world. That element is innovation – without which it would be impossible for progress to be made in any segment of society. Just as the artist endeavours to improve his interpretation and conceptions through innovation, the commercial entity strives to improve its end product or service through experimentation with new methods and materials. Our constant search for a new and better way in which to perform and produce is akin to the questionings of the artists whose works are represented here.

One could call Murphy's interpretation of Attitudes definitively modernist in sentiment: an obsession with 'innovation' via 'new methods and materials.' Yet the association of 'new' with 'better' is couched within 'perform[ing]' and 'produc[ing].' It is as if Murphy has made the modern the postmodern, avowing that the definitive dematerializing attribute of conceptualism is still a push to generate object or commodity. Many artists involved with Attitudes probably scoffed at this; Szeemann himself would undertake much more unconventional means of financing future exhibitions. Yet Szeemann said of Philip Morris (and the PR firm Ruder Finn, which partnered with it as a sponsor), 'They offered me money and total freedom.' There is more than a hint of what would become a common task of contemporary curators: securing funding and

parlaying with those outside the art world, those who don't necessarily understand fully the complex premise of a work or exhibition. And we cycle back to Courbet's 'entrepreneurial' exhibition outside the Salon. It is in the conceptual moment that artists begin to put their trust in curators as managers. It is in this moment of diversification that, indeed, the contemporary art industry diversifies to the point of necessitating a fresh (or refreshed) position. The curator must understand the avant-garde aesthetically and commercially, combining the two to turn something that is new and thus vulnerable into something that is nothing short of invincible. The curator ushers forth the avant-garde, not making, but shaping, it new.

In this way, Murphy's statement articulates the residue of modernist marketing that clung to conceptualism through the curator. As a dealer-curator, Seth Siegelaub expands the advocacy of early avant-garde dealer-curators in America and Europe, such as Paul Durand-Ruel, who represented many Impressionists, and Alfred Steiglitz, who championed early photography. O'Neill writes of the way Siegelaub had to work to make the artworks he selected and, in fact, promoted – such as Robert Barry's *Inert Gas Series*, which involved the release of gas into the atmosphere – 'palpable.' Siegelaub did so by producing basic-but-sleek fold-out poster-invitations, in a way, a step backward from conceptualism to minimalism, in which aesthetics are articulated rather classically. These invitations, forerunners of the impeccably designed exhibition invitations of the 1980s and 1990s, have become, like many publications of this period, expensive historical artifacts. As O'Neill explains, Seigelaub also took out text-based ads in *Artforum* for artist Douglas Huebler that became part of his art. One reads: 'This ¼ page advertisement (4½″ x 4¾″), appearing in the November 1968 issue of *Artforum* magazine, on page 8, in the lower left corner, is one form of documentation for the November 1968 exhibition of DOUGLAS

HUEBLER.' This would presage artist ads in *Artforum* in the 1970s and 1980s, such as Lynda Benglis's notorious 1974 ad featuring a photograph of her nude in sunglasses, holding a dildo at her crotch.

The confusion between artist and curator characterizes the conceptualist moment – all art-world roles went through a deliberate, gleeful shakeup – but it was not always an amicable thing. Artists were hostile to the powerful Harald Szeemann on more than one occasion. Although he was not invited to participate in Attitudes, French artist Daniel Buren wanted to. Two artists in the show offered him space, but instead he placed his characteristic striped posters around Bern, and was subsequently arrested by police for installing works on public property. The curator was becoming an endorsing force, especially with an institution behind him. He could orchestrate the kind of rebellion that was appropriate only in his gallery-cum-laboratory. In a 1972 *Artforum* review of Documenta 5, British art critic Lawrence Alloway claims that a group of New York women artists felt Szeemann had ignored them, and after complaining and asking him to contact them, nothing really happened. More well-known is the manifesto (oddly but appropriately, a modernist form) signed by several artists, including Donald Judd and Sol LeWitt, which accuses Szeemann and his co-curators of presenting their work in themed sections without the artists' consent. Alloway also notes that land artist Robert Smithson later wrote in an open letter to the magazine *Flash Art*, 'I do not want to participate in international exhibitions which do not consult with me as to which work I might want to show.' In *The Curator's Egg*, Karsten Schubert notes that Judd, for 'over nearly four decades of his career…[acquired] a fearsome reputation as the uncompromising defender of his art, forever berating curators, collectors and dealers for being blind to what his sculpture required in order to exist at all.'

Such protests are both eerie and laughable today, for the curator of such prestigious international events as Documenta and the Venice Biennale has been accorded such power and autonomy, and there are so many artists vying to be shown, that many artists cannot, in light of their fragile careers, afford to be so principled. Still, the question lingers in the twenty-first century: what are the moral dimensions of the curator becoming a creator by using other artists' work as raw material? The romanticization of the curator plays an integral part in this query. The curator's liberation in the conceptualist moment, his transition from caretaker to connoisseur, generated a persona that could be as intimidating as it was supportive and avuncular. In a March 2013 panel discussion at the Museum of Contemporary Art Detroit about Jens Hoffmann's 'response exhibition' to Attitudes, cheekily titled When Attitudes Became Form Become Attitudes, gallerist Susanne Hilberry recalls Sam Wagstaff, famous curator, impresario and lover of photographer Robert Mapplethorpe: '[He] had a very intuitive, emotional response to work. The way he appreciated things was…almost unpredictable. He walked around with a volume of poems by Yeats and a book of sayings by Logan Pearsall Smith… He was this combination of somebody who was casual, elegant and perhaps when you first spoke with him you wouldn't think he had the kind of insight and interest in new art [that he did].' The curator-connoisseur keeps you guessing. In demystifying exhibition- and art-making, and then remystifying them on new terms, the curator self-mystifies, becoming alluring and vexing in equal measure.

The curator is a condition of the contemporary. The proliferation of ideas and works in the 1960s and 1970s was nothing compared to that of the 1980s. It was in this decade that what we now call 'the artworld,' a term attributed to critic Arthur Danto in the 1960s, fully emerged. Says critic Jed Perl

of 1980s New York: 'The size of the art scene had expanded so dramatically – and so much of the expansion added so little to the general level of quality – that while there was certainly as much good work being done in the 1980s as there had been in the 1950s, it was now impossible for any but the most assiduous gallery-goer to pick out the artists who were really working along, pursuing personal views.' According to scholar Bruce Altshuler, in 1949 there were only around twenty American contemporary-art galleries, with the number of collectors investing in 'advanced work' around a dozen; by contrast, there were approximately 1,900 single-artist exhibitions in New York in the 1984–85 season alone. In a 2014 *Financial Times* article, writer Harald Falckenberg cites a claim that more art was sold in the 1980s than 'in all previous centuries combined.'

It follows that the 1980s art-world boom in America privileged not the curator but the dealer and, actually, the critic. The art critic may have risen as an authority in the modernist era, around mid-century, as typified by abstract expressionist–extolling Clement Greenberg, but it was in the 1980s that cultural consumerism surged, with an accompanying glut of culture writing. Robust, well-read alternative weeklies, their exemplar the *Village Voice*, popped up through the 1990s in every major urban centre, with staff writers able to make a living at their trade. Roger Ebert and Peter Travers followed the 1970s example of Pauline Kael in film criticism; Greil Marcus and Kurt Loder followed the 1970s example of Lester Bangs, Dave Marsh and Robert Christgau in music criticism. There has never been a way to quantify or prove a critic's influence on a medium or its success, but it is incontrovertible that many critics of this time were powerful, feared and loathed. Sonic Youth's 1983 song 'Kill Yr Idols' begins, 'I don't know why / you wanna impress Christgau.'

It is telling that the few critics still working and well-recognized in the art world were already busy and authoritative

in the 1980s. Peter Schjeldahl, now at the *New Yorker*, worked at the *Village Voice* through the decade. Roberta Smith began at the *Voice* and in 1986 moved to the *New York Times*, where she remains. In addition, highbrow visual-arts journals proliferated, such as the influential, avant-garde–allied *October*, founded in 1976 by *Artforum* alumni Rosalind Krauss and Annette Michelson. Trade-oriented alternatives to *Artforum* also appeared or expanded: *Art Monthly* was founded in 1976; *Flash Art*, which had been around since the 1960s, opened its New York office in 1980 under the editorship of soon-to-be-art-world-mogul Jeffrey Deitch; *Modern Painters* was founded in 1987; *Art in America*, which had been around since 1913, was rebooted under the editorship of Elizabeth C. Baker beginning in 1974.

As art historian and theorist Beti Žerovc notes, the critic, acting in concert with the ever more popular and successful dealer, was so influential during this time that 'studies of the art system published in the 1980s, which may otherwise be excellent, today seem out of date.' The curator's management of the avant-garde in the 1960s and 1970s had turned into a full-fledged business, one from which actual curators, who have always tended to view their activities as outside commercialism, shied. Arguably, in the 1980s, there was a renewed divide in the Western art world between America and Europe. A rash of new conservative regimes were affecting institutions on both sides of the Atlantic, but in Europe, as evinced by the experiences of the young Hans Ulrich Obrist at places like Kunsthalle Zurich, where Szeemann had ended up after acrimoniously parting with Kunsthalle Bern and pursuing freelance work, more public monies were being invested in culture. In many respects, the contemporary curator, very much a European invention, lay in waiting during this time.

In America, under Ronald Reagan, institutions suffered, yet the demand for art was proportional to the economy. The

orgies of success of traders in Wall Street in the 1980s were a kind of expression of the avant-garde impulse inherent in American capitalism: leveraged buyouts were just one of the ways in which Wall Street was making it new. Moving into the millennium, the economy would continue to have much in common with the avant-garde and its curatorial ambassadors, with traders attempting to substantiate and reify complex, fleeting notions of loans and investment.

In 1980s New York, as prices for artworks rose in proportion to the cresting economy, dealers stepped in to assure collectors – now interested in work not merely for aesthetics or philanthropy but for status and even as an investment – that what they were paying for was worthwhile. Dealers had grown in stature in the art world alongside the avant-garde. When American painting took off in the 1950s, dealers like Betty Parsons, Ileana Sonnabend, Leo Castelli, Sidney Janis and Paula Cooper nurtured artists like wealthy relatives; this filial relationship would be – but in most cases was not yet – fulfilled by the curator. A new 1980s generation of art dealers, among them Mary Boone, Larry Gagosian, Barbara Gladstone, Marian Goodman, and Janelle Reiring and Helene Winer (of Metro Pictures) were steely and shrewd. Reiring and Winer, in the manner of the 1960s curators who demystified and then remystified art, developed a stable of artists that would become known as the Pictures Generation, post–pop art figures like Cindy Sherman, Richard Longo and Barbara Kruger, whose sleek, photo-based work acted as an ideological critique of 1980s consumerist excess, but was also, in the minds of collectors and advertisers who co-opted it, complementary to it. Other dealers – famously, Boone – became curators of painters, developing stables of mostly male figures, each with a swaggering, neo-Romantic persona. In the thriving New York art world of the 1980s, it was the dealer who dictated who was in

and who was out. Value abetted value to create works that achieved notoriety simply because they were expensive.

When the American economy entered a recession in the early 1990s – with the art market experiencing a definable, devastating crash in the spring of 1990 – dealers were made examples of for their avant-garde approaches to selling. Siegelaub's materialization of Robert Barry's gases through beautifully designed invitations might, in this context, be compared with Boone's instating of waiting lists for in-demand artists, which, her detractors claimed, caused inflation by raising prices of works that had not yet been made. Perverting and elaborating on the tactics of Siegelaub, Boone took it upon herself to promote non-existent art.

Dealers would remain important figures in the 1990s and beyond: Charles Saatchi, who had collected since the 1960s, brought to prominence the Young British Artists, Damien Hirst among them; current power dealer du jour is New York–based David Zwirner. But never again would dealers and art critics inhabit the cut-and-dried oligarchical positions they did in the 1980s. In that decade, a work of art's value could be easily quantified by the market and the press. In the dispersed and tenuous 1990s, however, the contemporary curator gained a toehold as the main imparter of value.

The 'power' or 'star' curator of the 1990s was thus a concomitant of institutional uncertainty and attack. The right-wing Western governments of the 1980s, notably in America and Britain, made drastic funding cuts to the arts or, when unable to, vocally questioned the legitimacy of such funding. Endemic is the antagonistic relationship toward the National Endowment for the Arts that defined Reagan's tenure. He attempted to abolish the agency when he first entered office in 1981, but failed to get sufficient support from Congress. By 1989, the NEA came under public scrutiny for its support of artists such as homoerotic photographer Robert Mapplethorpe

and Andres Serrano, whose *Piss Christ* depicted a crucifix submerged in urine. In 1990, several performance artists went to court (and won) when their NEA grants were nervously vetoed by NEA chair John Frohnmayer. The debate raged on through the 1990s and 2000s, with right-wing politicians becoming more vociferous in their objections to government funding of art. While Napoleonic imperialism certainly lived on in the neo-conservative late-twentieth century, it was without the attendant, nationalist commitment to culture.

The examples of Serrano and Mapplethorpe suggest it was not only the right wing that put major museums and galleries under pressure. In the 1980s, it was dealers, not large institutions, who advocated for the work of artists deemed controversial. In many cases, dealers, in showing such work, valiantly stood by their artists and their right to be avant-garde, continuing a hallowed twentieth-century alliance between noisome, bohemian maker and tolerant, bemused patron. By the 1990s, many museums and galleries were so distanced from the display of controversial work that its appearance in these venues, an obvious attempt to retain or regain relevance, was, as the NEA controversies suggest, novel and shocking. Add to this the budding trend in early 1990s artwork of directly examining, critiquing and deconstructing the perceived exclusions and elitism of museums, and the major art institution was under attack from both sides of the political spectrum.

Who would stand by the latest iteration of the avant-garde in a recessed economy? How would the art institution assert itself and stay alive? The answer lay in audiences: crowds and donors became crucial to survival. The 1990s were marked by the significant development of the blockbuster museum show; the associated initiation of marketing teams and demographic research, something almost non-existent before the 1980s; the launching of museum-branded products, including books and postcards, sold in gift shops strategically placed near exhibition

exits; and the investment in renovations and additions helmed by 'starchitects' like Daniel Libeskind and Frank Gehry, whose brashly egoistic projects became the primary impetus for visitors to come. Major art institutions also realized that the artists who were critiquing them could, if embraced and exhibited, demonstrate their contemporary savvy. What better way to attract broader demographics than to show work pertaining to the exclusion of those very demographics? What better way to change the perception of the museum as staid and elitist than to show work that drew attention, in the form of a brave corrective, to these very accusations?

Audience-courting thus defines the institutionalization of the decade's major aesthetic fixations: identity politics, as typified by the divisive 1993 biennial at the Whitney Museum of American Art in New York, which contained an unprecedented number of works by women, non-white and queer artists; an ongoing commitment to controversy and (often juvenile) provocation, as typified by the 1997 exhibition of the Saatchi collection at London's Royal Academy entitled Sensation, which, when it came to the Brooklyn Museum in 1999, was denounced by New York mayor Rudy Giuliani as 'sick stuff'; relational aesthetics, in which artists engage in social practices in galleries or museums as a way of acknowledging audiences and institutional frameworks; and biennials, nationally or internationally ordered group exhibitions with distinct institutional ties and global-tourism mandates, more than forty of which were inaugurated during the decade.

In all of these trends, the curator dominates, indispensable as agent, ambassador, organizer, facilitator and provocateur. This was already the case in the 1960s, but in the 1990s, the curator moved from eccentric, enterprising amateur to professional necessity. As with Barr and MoMA, the museum of the 1990s befriended the avant-garde as a means of survival. Before the decade, no one had seen the curator doing so much in so

many places, and wielding so much power. So it was that the curator, who for centuries in her incipient occupation was seen as a wan librarian type, cataloguing objects in backrooms, became the mouthpiece for institutions, artists and their ideas. The curator had apotheosized into an outreach connoisseur. If the 1990s and 2000s signalled the triumph of audience-oriented art, it was the curator, equally triumphant, who was recruited to make this happen. In the words of Paul O'Neill, the 1990s marked the 'supervisibility of the curator.' This curationist moment would last for almost two decades.

The idea of the curator as a charismatic, magical organizer of exhibitions persists. Those committed to contemporary art still prefer to see the curator in the vein of the pioneering Szeemann: one who uses an eccentric horse sense in combination with an encyclopedic knowledge of art and philosophy to juxtapose deftly, creating thoughtful, challenging and surprising exhibitions that change the way we see art and the world. While it is true that more figures like this exist than ever before, it is also true that they comprise only a handful of those doing curatorial work. Nonetheless, such star curators, like Obrist, most of whom began their careers during the contemporary-curator heyday of the mid-1990s, are responsible for how we understand and talk about the industry of curating today. They are curators of curators, filling ambassadorial roles in order to elucidate the most hallowed iterations of the profession to the art world and beyond. They are the profession's face.

While the present-day star curator's efforts are authorial and often predictable, it is much too simple to reduce this to sheer egotism. As we have seen with Obrist, star curators are aware of their vulnerability, voicing self-effacement in response to their celebrity. And why not? Their role in their respective institutions is prominent yet vague. What exactly do they do?

Are they distant mandarins who force-feed us super-theoretical art? Hyper-professionalized agents – effectively business consultants – working for high-powered international cultural organizations? Bridges between artist and audience, showing us the best of what contemporary culture has to offer, and translating it in an effective, accessible way? The last proposition is idealist, the former two pejorative. One thing is certain: all contemporary star curators possess flexible intelligence and learning, are effective parlayers and do not shy away from discussing the problematic nature of their positions. Indeed, a willingness to discuss the contradictions, even the hypocrisies, of contemporary curating, especially in the context of institutions, might be the primary characteristic of the star curator.

This said, certain aspects of the star curator's job are more visible than others, and there are particular ways in which star curators prefer to critique what they do. The job description may seem complicated from afar, but it can be reduced to what the twentieth-century curator has always done: parse, manage and thus act as a type of midwife for the avant-garde, the new. The curator remains in charge of *stuff* – and since the turn of the millennium, it's more stuff than ever. What's different, however, is that the contemporary curator has come to play a pivotal role both in cataloguing stuff and generating it. When the contemporary curator's job altered from advocating for new objects (the modernist era) to advocating for new ideas (the conceptualist era), to advocating for herself as the newest institutional entity, she changed the avant-garde forever. The star curator has created an incestuous cycle that signals the end of the avant-garde. Instead of finding and advocating for the new, she immediately orders and manicures it, negating the very possibility of newness.

This is hardly a fresh idea, although the curatorial establishment is not ready to acknowledge it, and when it does so, tends to adopt a rhetorical or obfuscating tone. In *The Curator's*

Egg, first published in 2000, Karsten Schubert explains one key, fascinating institutional root of the avant-garde's demise: the drying-up of available historical works in the market after the late 1980s. 'The collections of most old museums are, in effect, "closed,"' he asserts.

> That is to say the lack of available historic works of exceptional importance makes it impossible for institutions to acquire works of the kind that would dramatically change the balance and overall character of their holdings. The only field that is constantly replenished is that of contemporary art… Under these conditions the concept of the avant-garde has become truly notional – today's museum culture has made the discovery, interpretation and historicisation of new art virtually simultaneous.

The collection of contemporary artwork by institutions, Schubert notes, poses any number of logistical problems, making 'arguments about the preservation of old master paintings look straightforward and clear cut in comparison.' Understandably, collection itself has created a mini-industry within large collecting museums and galleries, from storing and preserving the work (which can be made of esoteric, obsolete and highly ephemeral material) to creating dossiers about how to install the work in a variety of potential future situations.

It may surprise those outside the art world to know that building institutional collections in many cases rivals Szeemannesque 'exhibition-making' as the main activity of contemporary curators. However, many star curators working today are employed by institutions that, in the *kunsthalle* model, do not have permanent collections. Obrist is at the Serpentine in London, a non-collecting institution; Massimiliano Gioni, curator of the 2013 Venice Biennale, is at the non-collecting

Nicola Trussardi Foundation, and the New Museum in New York, which only occasionally collects; Okwui Enwezor, who will curate the Venice Biennale in 2015, is at Munich's Haus der Kunst, also non-collecting.

Such curators may not collect in an official capacity, but they are powerful arbiters influencing the shape of collections worldwide. Their exhibitions behave like high-end fashion shows, generating desirability for specific works and, perhaps more importantly, asserting trends. (Think of Meryl Streep's Miranda Priestly in *The Devil Wears Prada* unintentionally recontextualizing Theodor Adorno and Max Horkheimer's 1944 idea of 'the culture industry': '[T]hat blue represents millions of dollars and countless jobs and so it's sort of comical how you think that you've made a choice that exempts you from the fashion industry when, in fact, you're wearing the sweater that was selected for you by the people in this room. From a pile of stuff.') As is the case in fashion, which has always embraced the capitalist nature of the avant-garde more readily than the art world, a show with buzz can have a profound effect on how those in the industry think and create. An alliance with a star curator makes an artist's career, among other things facilitating their collection by institutions sensitive to their work's specific needs. It can also permanently associate an artist with the sensibility of that star curator, as if the artist has been inducted into a sort of tribe.

As artists began to work with ambitious materials, and as difficult-to-collect forms such as performance and video art became more and more common in the 1990s, the curator became institutional dealer par excellence. It is only recently that dealers have learned how to behave as curators, forging enterprising transactions with institutions to facilitate the purchase of difficult-to-commodify works. Participatory art and performance in particular is so deeply associated with the contemporary curator's repertoire that to speak of origins is a

chicken-or-egg debate: which came first, performance art or performative exhibitions such as When Attitudes Become Form or Lippard's index-card instructional actions? In one of its 2011 draft additions reflecting the expanded use of *curate* as a verb, *The Oxford English Dictionary* dated the transitive, passive construction *curated by* to a 1981 review of a performance at New York City's legendary experimental SoHo space, the Kitchen: 'The Kitchen presented three different programs of "New Performances from PS 122," curated by and including Mr. [Charles] Dennis.' There is a case to be made for the art world's mindfulness of audiences being the very thing that began to change *curator* into a verb. In order to exist, any performance must secure a venue, draw spectators and translate instructions or intentions for execution into a real-life scenario. All these things are hallmarks of the contemporary curator's activity.

It follows that, from about the mid-1990s, most prominent artists didn't just want a curator as advocate, but needed one to initiate, realize and in many cases give meaning to their work. 'Curator art' or 'biennial art' became the last genre of the avant-garde, a sometimes unwitting, decadent parody or commentary on its one-hundred-year trajectory. Reactionary works pushed against coded forms of looking and consumption presumably upheld by museums, galleries and art events, but in many cases existed only by virtue of these entities. Installation-oriented, 'curatable' art became favoured even in more traditional media. Photographers, for instance, became photographic artists; Christian Boltanski, Wolfgang Tillmans, Jeff Wall and others became popular for producing images with sculptural, site-specific elements.

As a result, most star curators began to groom a stable of iconoclastic artists with ties to performance and audience engagement, advantageous professional alliances that boosted the institution-affiliated curator's authenticity. The most famous

current example of this is perhaps Marina Abramović and Klaus Biesenbach, who curated Abramović's 2010 retrospective at MoMA, setting a new precedent for the institutionalization of performance art. (The exhibition consisted of conspicuously attractive performers, some naked, reenacting Abramović's performance works from the past, while Abramović performed a new work, *The Artist Is Present*, for which crowds of people lined up for the chance to sit across from her in a sort of durational staring contest.) Abramović and Biesenbach remain close friends. In early 2014, before the premiere of artist Matthew Barney's new film, *River of Fundament*, Abramović was whisked away from the media by Biesenbach, who reminded her they were late and needed to find their seats, telling reporters that their questions to Abramović about actor Shia LaBeouf's latest performance-art project, plainly influenced by her work, were a waste of time. 'What if he invented the wheel tomorrow?' Biesenbach asked the reporters. 'The wheel is invented. She did it, right? And we all know it.'

In her 2012 book, *Artificial Hells: Participatory Art and the Politics of Spectatorship*, critic Claire Bishop cleverly describes this 1990s social turn in art through the marked shift in vocabulary it effected: 'the artist is conceived less as an individual producer of discrete objects than as a collaborator and producer of *situations*; the work of art as a finite, portable, commodifiable product is reconceived as an ongoing or long-term *project* with an unclear beginning and end; while the audience, previously conceived as a "viewer" or "beholder," is now repositioned as a co-producer or *participant*.' The irony of the statement as regards audience-courting contemporary museums or galleries is obvious. With its new branding initiatives and marketing outreach, the cultural institution wants all of these things too. In particular, the cultural institution wants, like participatory art, a lack of a finite relationship with its audience. Go to an exhibition, then take in a screening, eat at the café, shop at the

gift shop and bring a pamphlet home with you to consider your next outing. Through audio and smartphone guides, touch screens and videos, and play spaces for kids, in addition to traditional didactic panels, the cultural institution wants your experience to be thoroughly interactive, satisfying from an investment standpoint (i.e., you felt you got your money's worth) and, like participatory art, everywhere and ongoing.

Bishop's statement is also useful in terms of its implications for a discussion of the ways in which museums court audiences through avant-garde practices, although Bishop, while critical of participatory art, maintains faith in its radical potential. She is emphatic in contrasting her understanding of participatory art – which still, especially in non-Western contexts, can occur well outside the commodifying purview of cultural institutions – with the aforementioned 'relational aesthetics,' a coinage from curator-writer Nicolas Bourriaud, whose eponymous book (published in French in 1998, in English in 2002) made, in Bishop's words, 'discursive and dialogic projects more amenable to museums and galleries.' This is putting it mildly. The relational-aesthetics movement is likely the first example of a curator naming a movement in contemporary art and, given the curator's significant role in unintentionally dismantling the avant-garde, will likely be the last. Bourriaud's book might also have doubled as a rule book for the new museum: no avant-garde movement has become so rapidly institutionalized. The fact that most artists associated with relational aesthetics, like Rirkrit Tiravanija and Carsten Höller, are among the most successful and powerful artists working today, and that, despite the apparent difficulty of their work, have managed to become affiliated with the most prestigious international collections and private collectors, speaks volumes about the institutional and curatorial drivers of this movement.

It is most salient for the purposes of this short study to dwell on the implications of relational aesthetics' unmistakable

institutionalization: the 2008 show theanyspacewhatever, curated by Nancy Spector at New York's Guggenheim Museum and featuring many big names associated with the movement since the mid-1990s, among them Maurizio Cattelan, Liam Gillick and Pierre Huyghe, in addition to Tiravanija and Höller. Yet, 'unmistakable institutionalization' seems inept here, for the exhibition was a bookend to the (institutional) beginning of the relational-aesthetics movement, the 1996 group show Traffic, curated by Bourriaud at the Musée d'art contemporain in Bordeaux, France. In other words, relational aesthetics was institutional from the start. Regarding Traffic, critics seemed unclear as to its purpose. Carl Freedman, in a contemporaneous review in the magazine *Frieze*, describes it as 'ambitiously funded' but 'unhelpfully vague,' its 'primary beneficiaries… tending to be the participating artists and their associates.' Projects such as Dominique Gonzalez-Foerster's room in which viewers were encouraged to draw plans of their childhood homes, or Tiravanija's groupings of cardboard tables and chairs around a mini-bar, were certainly interactive, but to what end? Was this art-as-therapy? Art-as-party? The dubious transformative import of most if not all works remained confined to the institution in which they were displayed.

If Traffic was vague in its intentions, theanyspacewhatever seemed cynically clear. In the twelve years between the two shows, star curators like Massimiliano Gioni, Hans Ulrich Obrist, Daniel Birnbaum and Beatrix Ruf had all, to varying degrees, latched on to this movement, which, to quote the catalogue jacket copy for theanyspacewhatever, involved a group of artists who 'claimed the exhibition as their medium.' Instead of being threatened by these artists, who might have been seen as upstart contemporary curators, star curators stepped in as glamorous facilitators, liaising with museums and galleries, initiating tricky paperwork pertaining to insurance and liability issues around the involvement of real people

in the art, collaborating on and arranging what could be complicated installs, and, of course, speaking and writing at length about the importance of such art. The final word on theanyspacewhatever remains with critic Jerry Saltz, who reviewed the show for *New York* magazine, emphasizing his experience sleeping overnight in Höller's *Revolving Hotel Room*, which was just that, a revolving hotel room installation at the Guggenheim, booked solid for the duration of the exhibition for between $259 and $799 per night. Saltz described relational aesthetics as beginning in the manner of a 'palace coup' but quickly attracting 'a legion of sheeplike curators [who have] embraced it with a vengeance.' Saltz noted that the exhibition catalogue had twenty essays written by curators, and that the exhibition, although curated by a woman, woefully included only one of the many women associated with the movement. Reading Saltz's review more than five years later, one is struck by its percipience, by how this kind of art has come to define New York's culture industry. Recent examples of relational aesthetics in New York include MoMA's 2013 Rain Room and the New Museum's 2012 Höller retrospective. In a city that has emerged, in direct synchronicity with the development of relational aesthetics, as a kind of Disney World for grown-ups, this self-consciously curated, installation- and performance-oriented art reigns supreme, generating lineups to rival those for nightclubs, and providing fodder for countless social-media selfies and blog posts.

Unlike relational aesthetics, biennials have been a staple of the art world for more than a hundred years, with the Venice Biennale established in 1895 in the model of then-popular world's fairs and universal expositions, an art-world Olympics with an unabashed agenda of trying to foster the international art market. (In the 1940s through the 1960s, the Venice Biennale housed a sales office to help artists find buyers for their work.) By the 1990s, then, the biennial was seen both

as a stale idea and one ripe for reimagining. Popular and acclaimed biennials founded in the 1980s as, in large part, cultural-tourism draws, notably the Havana Biennial (1984) and the Istanbul Biennial (1987), contributed to their renaissance during the following decade. Like museums and galleries, many cities with a middling tourist industry became keen on rebranding themselves through the then-trendy global-is-local ethos. (Film festivals, also prevalent in the 1990s, had similar motivations.) The audience-driven nature of biennials meant that star curators had a close relationship with their development in the 1990s, although it wasn't until the 2000s that, in classic contemporary-curator mode, discussion of the biennial's plain-as-day market-driven aspects effected a demystification and then a remystification of the very notion of the biennial, putting the curator in an even more central place.

'It has become a national sport to dismiss biennials,' said Massimiliano Gioni at a talk at Toronto's Power Plant in March 2014, effectively summing up the ways in which star curators became ascendant in 2000s biennial culture. 'What I like about biennials is that they are institutions where the very meaning of an institution can be called into question every two years.' And so it was that in dismantling and querying biennials, star curators became the focus for these biennials. Two pivotal examples, both of which can be directly associated with Gioni, are Manifesta, an itinerant European biennial founded in 1996, and the 2003 Venice Biennale, directed by curator Francesco Bonami.

Manifesta might be seen as the art world's response to (and arguably its mimicking of) the dissolution of the Soviet Union as well as the Maastricht Treaty and its initiation of the European Union. The first Manifesta took place in Rotterdam and was collaborative: chief curator Katalyn Neray worked with four 'associated curators,' Rosa Martinez, Viktor Misiano, Andrew Renton and Hans Ulrich Obrist. The

manifesto of Manifesta is everything classic avant-garde mani-festos were not: open and warm in its questioning, ambitious only in the sense that it seems to want to be everything to everyone. 'Manifesta 1 is about life and emotions, depressing and funny ones / about all the big troubles and great pleasures involved in communication / about migration / about having a place and having no place at all / about integration / about the necessity of imaginary worlds / about the necessity of inventing new relations in this world.' Reading almost as a naive parody of the modernist invective, this is classic utopian thinking, *utopia* being Greek for *good place* and *no place*. It is also contradictory: how can you curate *everything*? However earthy, hopeful and free-spirited, Manifesta was and is obvi-ously an industry. Although placeless, or rather multiply placed, it finds significant grounding in its headquarters in Amsterdam, where it produces a journal, symposia, books and other entities intrinsic to the activities of professional curators. Its board members, past and present, form a kind of European curating cabal; its sponsors, past and present, run the gamut from corporate to public, the latter a list of international arts coun-cils, ministries and foundations. In a weird echo of When Attitudes Become Form, Manifesta 1's principal sponsor was Philip Morris Benelux.

The 2003 Venice Biennale, its fiftieth edition, proposed something similar to Manifesta in its intent to be, in the words of director Francesco Bonami, 'a reaction to Harald Szeemann's persona' (Szeemann curated the Venice Biennale twice, in 1999 and 2001) and thereby to instigate 'community curating.' Szee-mann had been too dominant, too singular, too authorial, too canonized. It was time to demystify and disperse duties, and so Bonami pieced up the Biennale into sections, to which he assigned high-profile confreres including Obrist and Gioni, as well as artists Tiravanija and Gabriel Orozco. The title of the Biennale was Dreams and Conflicts: The Dictatorship of the

Viewer, the subtitle an apparently cheeky acknowledgement of what had driven the art industry, contemporary curation and the avant-garde since the mid-1990s. Writing for *Frieze*, Ralph Rugoff identified another irony: 'the only dictatorial attitudes accommodated by this Biennale were those of its curators.' Obrist, with Tiravanija and Molly Nesbit, co-curated an exhibition appropriately (yet again, not necessarily ironically) entitled Utopia Station, that, in the words of Rugoff, 'crowded the work of more than 160 artists into a cluttered lounge-like environment, replete with the obligatory computer stations and clubhouse ambience.' Curator Charles Esche of Eindhoven's Van Abbemuseum later quipped that 'as a project it was dressed up in a Che Guevara T-shirt, shrinking and consuming its own radical possibility.' Commenting on Obrist and company's use of 'utopia,' Esche noted that 'using the term the way Obrist did, without a sophisticated analysis, repeats exactly the same model in which the artist is at the service of the curator, the ultimate utopian – like Stalin, orchestrating everything.' Despite the notably mixed reviews, even hostility, directed toward the 2003 Venice Biennale, it and other international art events have continued in a similar vein.

The 2013 Venice Biennale, artistic-directed by Gioni with a team of curators, was entitled The Encyclopedic Palace, and, in its sprawling group show spread out over the Biennale's Giardini and Arsenale locations, teemed with art objects by contemporary as well as deceased and/or obscure artists. This commitment to outlying figures rather than Obrist's 'clubhouse ambience' might have been a refreshing shift, had a similarly cluttered effect not dominated. Here, the star curator presented himself as a hoarder, like Orson Welles's Charles Foster Kane at the end of *Citizen Kane*, presiding alone over a mansion of acquired stuff. Yet the comparison is not apt, for Gioni had his curatorial team and, despite its overflow, The Encyclopedic Palace was hardly encyclopedic, incorporating many usual-

suspect names and genres. Problems that had plagued the art world since the 1980s and 1990s abided, and the exhibition's apparent cluttered inclusiveness effaced its bureaucracy and orthodoxy. In a problem extant since the notion of globalism took off as a pet project of the Western art world in the late 1980s, non-Western artists seemed cherry-picked for their sociological and/or exotic, mystical qualities. And while the exhibition did include painters and drawers, who have held a tenuous place in the art world for decades, only a handful were formally trained, sane and alive.

A year before The Encyclopedic Palace, Carolyn Christov-Bakargiev unveiled her ambitious Documenta 13 – or, to use her favoured printed appellation, dOCUMENTA (13). Her scheme for this edition of the art world's influential avantgarde quinquennial shirked the time-based aspects of international art events, introducing a publication project before the event's opening. She commissioned many artworks that had a life beyond the event's closing. In addition to Kassel, the traditional headquarters of Documenta, she had several 'outposts,' including Kabul and Banff. And, of course, she rejected 'curator' as a title, instead calling herself and her international team 'agents.' In a 2010 interview with artist, curator and writer Carolee Thea, Christov-Bakargiev foretold of this gesture, claiming, in the context of her co-curation of the Turin Triennial, that she was 'intentionally moving the attention away from the auteur/curator,' but that she doesn't 'try to beat the spectacle,' which she considers an 'agent' or 'decoy' in the manner of Renaissance artists who did church commissions depicting Christian stories and themes while also conveying 'something else, something secret.'

Christov-Bakargiev was, then, perhaps indifferent to the press-preview kit for Documenta that featured, on an enclosed disc, nineteen photographic portraits of her. While Documenta has always been difficult to preview because its lineup is

traditionally kept vested until opening, Berlin journalist Nadja Sayej, in a hilarious, trenchant coinage published in a blog post affiliated with her web series ArtStars*, called this suite of portraits 'curator porn.' In Sayej's words, it featured 'various glamour shots of [Christov-Bakargiev] in a forest, lounging on a lounge chair, wearing business blazers, working hard, hardly working, throning it and more.'

Curator porn may be a mere decoy, but it is also content, a common method of marketing institutional shows and, especially, biennials. The more recognizably outfitted the star curator, the better. One might note that while the archetypal contemporary-artist outfit still skews toward anything-goes shabby-chic bohemian (especially for men), the one for the contemporary curator, as if to reflect her professional expertise in selecting and arranging, is tasteful, soigné, uniformed. Christov-Bakargiev is known for her voluminous curls and voluminous scarves; Obrist for his glasses and agnès b. suits, worn sans tie; Gioni for his boyish matinee-idol good looks; Beatrix Ruf for her close-cropped hair and black Pagliacci-style blouses; Biesenbach for his, to quote *W* magazine, 'large wardrobe of tailored Jil Sander suits.' Curator porn suggests the contemporary star curator must curate her very identity, not unlike a politician or a celebrity. In this respect, the contemporary star curator is indeed Christov-Bakargiev's 'agent,' behaving, in a glamorous iteration of the Roman colonial procurator or the Medieval curate, as the representative of a large organization or concept, the face of an event or exhibition before it has been unveiled to the public.

A less egregious iteration of curator porn might be the fixation of star curators from the mid-1990s onward on the history of, to use Szeemann's phrase, exhibition-making. It is curmudgeonly to look only askance at this. The history of exhibitions, rather than that of individual artworks and artists, has been so underemphasized in art-history programs as to create

generations of students with a very poor understanding of the conditions of artistic production, as well as of the nature and evolution of the art market. (The fact was certainly evinced during research for this book, which, despite curating's ascendance, felt positively magpielike.) The new attention paid to the history of exhibition-making since the mid-1990s is, however, not merely an enlightened form of pedagogy. Concomitant with the rise of the contemporary curator and curationist culture in general, it can smack of arch incestuousness. And the history of exhibition-making, when delivered by curators, takes on the fetishistic, de-/remystifying cast that is their wont, an exaggeration, perhaps, characteristic of any contemporary endeavour designed to establish and assert new canons. Bruce Altshuler's *Salon to Biennial* and *Biennials and Beyond*, for instance, both subtitled *Exhibitions That Made Art History* and published in 2008 and 2013 respectively, comprise a history of avant-garde exhibition-making from the Salon to the present-day that acts as an indispensable primer for anyone interested in the topic. The set is published by Phaidon in large, gorgeously designed editions, chock full of previously unavailable documents to form an important reference compendium. But the books are large and heavy, emphasizing, in consummate avant-garde manner, art for art's sake. They are easier to display on a coffee table than to read.

The primary de-/remystifier of the history of exhibition-making is star curator Jens Hoffmann, mentioned earlier for When Attitudes Became Form Become Attitudes, his 2012 response exhibition to When Attitudes Become Form. The title alone suggests the kind of playful poststructuralism on which Hoffmann has founded his curatorial brand. As an upstart curator in 1999, he co-organized the notorious 'Sixth Caribbean biennale' with puckish Italian artist Cattelan, inviting usual-suspect curator-friendly artists of that decade's biennials – Vanessa Beecroft, Douglas Gordon, Olafur Eliasson

and others – to go on vacation to St. Kitts. There had been no previous five events, and no actual biennial was staged for this hoax project. Instead, the artists sipped cocktails, swam and suntanned, with only some producing ephemera around the experience. Artist Ann Magnuson, who participated, summarized the biennial in a mock–*Gilligan's Island* lyric for the website artnet: 'Sit right back and you'll hear a tale / a tale of a fateful trip / to an island in the Caribbean / with artists who are hip / the curator was a prankster smarty pants / his young partner liked to smirk / they hosted a Biennial / but there would be no work / there would be no work.' Hoffmann, the Weird Al Yankovic of star curators, would go on, through the '00s, to engage in a dual parody and celebration of the art world, making a name for himself with response exhibitions at eminent institutions. His When Attitudes… show, held at California College of the Arts' Wattis Institute in San Francisco (where he was then director, and as such guided students at the affiliate institution's renowned curatorial-studies program), culled contemporary, younger artists working in the vein of Szeemann's original cohort. His 2014 Jewish Museum show Other Primary Structures was a response exhibition to the classic Primary Structures show of 1966 that effectively introduced late modernist sculpture to a wider audience, adding non-Western artists to the original show. Both projects are certainly critical of curationism, but at the same time are canon-asserting and celebratory of the curator's conceptual power. Like many contemporary academics, Hoffmann points out exclusions while also being the conspicuous arbiter of inclusions. His most recent book, *Show Time: The 50 Most Influential Exhibitions of Contemporary Art*, is yet another unintentional postmortem on the avant-garde, a beautiful coffee-table book asserting, through a list, a canon of shows that rarely predate 1990. The oxymoronic phrase *instant classic* comes to mind.

A different kind of response exhibition opened at the 2013 Venice Biennale, away from Gioni's Encyclopedic Palace at the Ca' Corner della Regina palazzo, now operated as an art space by the Prada Foundation. When Attitudes Become Form: Bern 1969/Venice 2013 was curated by legendary Arte Povera curator Germano Celant 'in dialogue with' artist Thomas Demand and architect Rem Koolhaas. An uncanny restaging of Szeemann's famous show, it might be deemed 'exhibitions porn.' It also belongs in the broader cultural context of 'nostalgia porn,' examples of which include the ongoing performances of Mozart's *Don Giovanni* at Prague's Estates Theatre, at which the opera debuted in 1787; period-precise Shakespeare performances at London's recently rebuilt Globe Theatre; rampant Hollywood remakes, from *Psycho* to *Carrie*; or album tours by reunited older bands, for which classic albums are delivered live, often start-to-finish. These phenomena can be inspiring as well as tedious; regardless, they are conspicuously, fundamentally anti–avant-garde. Their collective dictum might as well be 'Make it old.'

How odd, then, that one of the most emblematic shows of the 1960s avant-garde, When Attitudes Become Form, should fall into this category. Granted, it does so in a complex, ambiguous manner. The actual title of Szeemann's exhibition is, of course, Live in Your Head, a phrase that glibly sums up conceptualism, for which idea is greater than form. To resuscitate a constellation of conceptualist works, then, makes sense, or at least seems ready for facilitation; many such works are designed not to have a specific objecthood, a specific installation context, even a specific look or form at all. In a 1969 Swiss television documentary made about Szeemann's show, artist Lawrence Weiner summarizes his work's potential multiple lives, through place and time: 'The idea…is very exciting to me. This [the chipped-away square on the Kunsthalle's wall] is very unimportant compared to the idea. If I do this piece in Amsterdam

or New York it's exactly the same piece. Even though it may be a little bit different, a different kind of wall: it's still the same piece. I don't need to do it; somebody else can do it.'

As Catherine Spencer noted in her review of Celant's show, its pamphlet claimed a conscious distancing from 'a fetishistic and nostalgic dimension.' However, many elements of the exhibition suggested otherwise. The co-curatorial involvement of Rem Koolhaas and Thomas Demand likely contributed. Koolhaas has designed museums and museum spaces (such as a Serpentine Pavilion for his friend Obrist) as well as retail spaces for Prada; Demand is known for his eerie paper reconstructions of public and bureaucratic spaces, which are then photographed or filmed. Celant's enlistment of figures invested in display (think Barr's avant-garde department-store presentations), as well as in simulation, had a significant effect. The floor plan of Kunsthalle Bern was precisely mapped out onto that of the Ca' Corner, a fetishistic act that also drew attention to venue differences. Dotted lines on walls and the floor were drawn to indicate 'missing' works, the definition of which was multiple (unavailable, lost) but which, in the opinion of more than one critic, gave the exhibition the flavour of a crime scene, similar to the Dutch Room at the Isabella Stewart Gardner Museum in Boston, in which empty frames hang where Rembrandt and Vermeer works once did, marking their still-unsolved 1990 theft.

In effect, this 'live in your head' exhibition seemed all about the value of objects. Documents and photographs related to the original Attitudes, many lent to the exhibition from the Harald Szeemann archive at the prestigious Getty Institute in Los Angeles, were available for perusal on the ground floor. Spencer wrote that the show '[reeked] of money: from the couture-besuited guards keeping close watch on attendees, to the beautiful brick of a catalogue weighing in at about £75.' And although someone else 'could do it,' Lawrence Weiner agreed to recreate his work

for the exhibition, attending the opening with much fanfare, an American conceptualist grande dame.

Spencer likens Prada's place in facilitating this exhibition to that of Philip Morris in facilitating the original, although the difference is at least as telling. There has been, to sum up, a profound acceleration. Since 1995, Miuccia Prada, with partner Patrizio Bertelli, has, through their foundation, produced projects, collected art, devised a permanent exhibition space (designed by Koolhaas and set to open in Milan in 2015), held conferences, published monographs and established an award for curators. Few institutions, and no contemporary curators, could effect this kind of autonomous, broad-spectrum programming.

And Prada is not alone. Luxury brands, banks and other companies have fully embraced the curatorial ability to impart value, self-brand and court audiences through art. Some are working with 'real' curators; some are doing it on their own. The 'new and better way in which to perform and produce' that John A. Murphy of Philip Morris identified as such a vital lesson in his introductory note to the catalogue of Szeemann's original exhibition resonates today in corporate practice. The next logical chapter in this twilight of the avant-garde, after curators curating themselves and their own histories, is everyone else, including and especially companies, objectifying, fetishizing, appropriating and indeed curating curators – becoming and, in many cases, supplanting them.

'Curators are the best vampires.' So said Germano Celant, with considerable jocularity, at a lecture about When Attitudes Become Form: Bern 1969/Venice 2013 at the Reel Artists Film Festival in Toronto in February 2014. Celant's equation is not his alone. In the 2011 book *Curation Nation*, a plainspoken business-world guide about, as its subtitle proclaims, *How to Win in a World Where Consumers Are Creators*, writer Steven

Rosenbaum tackles the critics of content aggregation – and its most successful current digital news-media incarnation, the *Huffington Post*, which, like *Reader's Digest* before it, largely culls and organizes content rather than generating it anew. Rosenbaum looks back to his childhood scheme of gathering day-old papers and selling them door-to-door at a discount as an incipient understanding of what it means to, in his understanding, curate. Then he concedes that obstreperous U.S. businessman and sports mogul Mark Cuban, who owns Magnolia Pictures and the Dallas Mavericks, 'would call me a vampire,' later quoting Cuban: 'Don't let [content aggregators] suck your blood… Vampires take but don't give anything back.' (Here we might cycle back to Obrist's cultural voracity and reluctance to keep regular sleeping patterns.)

Director Jim Jarmusch's film *Only Lovers Left Alive* stars Tom Hiddleston and Tilda Swinton as centuries-old vampire lovers Adam and Eve. He's a reclusive musician tucked away in a warehouse apartment in Detroit; she's a bon vivant in Tangier. When it entered wide release in early 2014, critics echoed Celant's statement in reverse. Richard Brody, blogging for the *New Yorker*, called the film 'the second-most-intensely curated movie of the season' (the first being, in Brody's estimation, Wes Anderson's *The Grand Budapest Hotel*, also starring the eminently curatable Swinton). Edwin Turner, on his site Biblioklept, wrote an essay about 'curation and creation' in the film, inspired by Mike D'Angelo's *Nashville Scene* review calling Adam and Eve 'much more like curators than monsters.'

The idea of vampire-as-curator serves as an *amuse bouche* to how curation, in a manner very similar to the art-world chronology we have just seen, has infiltrated popular culture. In *Only Lovers Left Alive*, Adam and Eve turn their basic instincts – feeding on blood – into an elite expression of taste. Blood oenophiles, they source their food from hospital labs, abhorring feeding on actual people. In one scene, Eve shows

Adam her invention, a blood popsicle made of O negative, as if it's the latest creation of New York–based iced-treats purveyors People's Pops, self-described popsicle 'matchmakers' who 'couple fruits with herbs and spices and marry them into delicious and dynamic flavors.' Everything that Adam and Eve do, in fact, and everything that Jarmusch surrounds them with, evinces popular culture's understanding of curating as fine-tuned selecting and matching. Eve is so adept in her knowledge of the nature and provenance of objects that, as Turner notes, 'she merely has to touch [something] to know its age.'

Brody suggests *Only Lovers Left Alive*'s other metaphor is vampire-as-hipster, not far off from the first, but meaningful for implying the roles personage and persona play in imparting value. Adam and Eve are undead snobs who do not eat what humans eat. (They dismissively refer to humans as 'zombies,' and the particularity of their diet is reminiscent of outlandish celebrity riders; I thought of Grace Jones, who reputedly only consumes oysters and red wine.) And so it is that Adam and Eve's rarified perseverance has the distinct whiff of cult celebrity – because as they see it, straight celebrity is vulgar and best left to the zombies. Their good friend Christopher Marlowe, played by John Hurt, ascertains that he indeed wrote all of Shakespeare's plays, and it makes him cooler that he didn't get the credit. In a memorable scene, the camera turns to a salon-style wall of portraits in Adam's place – an exhibition, essentially – of all the bohemian cult celebrities he has known, and who were probably vampires, Buster Keaton and Edgar Allan Poe among them. Brody makes the astute observation that the film is 'in effect, a movie written to be performed by Patti Smith and Richard Hell' – cult celebrities par excellence, who, for some, can turn cool anything they touch. In a 2011 piece in *Grantland*, Brian Phillips calls Smith, an object fetishist and artist worshipper in the Catholic vein, the 'curator of rock 'n' roll': 'listen to *Horses*

now and it's impossible not to notice that Smith is absolutely hell-bent on re-curating rock's lost past.'

Madonna has also been called a vampire – and a curator. Her vampiricism seems twofold, first accumulating around her sang-froid approach to aging and sexuality, from her incubus/succubus kiss with Britney Spears at the 2003 MTV Video Music Awards to her ad for a 2010 collaboration with Dolce & Gabbana, in which she makes out with a young guy in an elevator (as the paparazzi scream for her) and leaves bloodlike lipstick traces on his neck. The D&G collaboration, for which she designed several models of sunglasses, suggests Madonna's other, well-known vampiric/curatorial role, as a culler of cultural modes and cues, and an imparter of value. As a May 2014 guest of comedian Marc Maron's podcast, drag superstar RuPaul commented that 'Madonna is a curator. She understands how to market. That's where we are in culture today. The world has caught up to what she was doing. [Fashion designers] Tom Ford…or Karl Lagerfeld, they are curators. Tom Ford doesn't know how to sew, Karl Lagerfeld doesn't sew. Madonna's the same. She sings, and does it all – not the greatest, but she knows exactly what to do and how to put it together. And that's genius.' RuPaul suggests curating – in Madonna's case, amassing and fusing an assortment of pop-cultural and counter-cultural texts, from Old Hollywood and German expressionist film to the ballroom voguing scene of late-1980s Harlem – has become *the* way in which celebrities and entrepreneurs super-charge their brands and attract audiences. It is hardly a stretch to assert that it is precisely the ethically shady side of this – its vampiric/parasitic qualities, feeding on previously authored works and styles – that makes it alluring. It's also what makes it dangerous, wobbly. Witness the scathing reviews for Lady Gaga's 2013 album *Artpop* or Jay-Z's 'performance art film' *Picasso Baby* of the same year, which, with their pandering art-world obsessions, risibly dive into the middle of the curationist fray.

Madonna is now a curator in the stricter sense. In September 2013 she co-initiated Art for Freedom with *Vice* magazine, an online exhibition featuring art by various artists on the topic of human rights. But Madonna is not the only curator of Art for Freedom. She appoints guest curators, like Miley Cyrus and Katy Perry, to select art as well. Obviously Cyrus's and Perry's powers of connoisseurship and contemporary-art know-how are not the main reasons why they've been selected. Their celebrity lends value to Art for Freedom, creating an audience for it and making themselves ready subjects for Madonna's curation. The curated celebrity curator: this is curator porn 2.0.

And so it is that not only galleries and museums, but also corporations, businesses, cultural organizations and not-for-profits, are using the model of the curator to imply their products and services have been created, selected and expertly managed in their buyers' favour. Obviously, an air of glamour and authority attends this intervention. These so-called experts, like art-world star curators, are demystifiers who remystify. Their amateurism tempers the remoteness of their celebrity, as if they've hand-selected a few books off their living-room shelf for you to take home with you. Mid-1990s curators like Obrist, inspired by Szeemann's out-of-the-box, untrained approach, worked to legitimate their practices and, arguably, to ascend as brands. At the present moment of their reckoning, art-world star curators are seeing the converse taking place. They are being complemented and supplanted by dilettantes.

Examples of guest curators like Miley Cyrus and Katy Perry are everywhere and alone could fill a small book. The music festival is perhaps the celebrity curator's most salient provenance, for, as we have seen, the use of *curate* as a verb began, according to *The Oxford English Dictionary*, with organizers of performances. Although Perry Farrell, ex-member of Jane's Addiction and founder of the Lollapalooza festival in 1991,

was not called 'curator of Lollapalooza' then, he is now; same for Belle & Sebastian, who organized the Bowlie Weekender music festival in 1999, a precursor to the U.K.'s now-massive All Tomorrow's Parties festival, and were called 'curators' of Bowlie when it was revived at ATP in 2010. Similarly 'curated' concerts and festivals by the likes of SBTRKT, Jay-Z and others are now abundant, obvious manifestations of their celebrity initiators' tastes, affiliations and brands.

Art institutions are branching out from the realm of star curators to bona fide stars. Toronto has seen several recent examples. At the Art Gallery of Ontario, pop philosopher Alain de Botton's project with art historian John Armstrong, Art as Therapy, opened in May 2013. An extension of their book of the same name, the exhibitions activate institutions' collections by framing them within the book's proposition that art can contribute to self-understanding and even self-actualization (the project was also staged at Amsterdam's Rijksmuseum and Melbourne's National Gallery of Victoria). Hyper-audience-driven, Art as Therapy is an egregious example of curationism. Instead of engaging the AGO's many curators to create an exhibition around its permanent collection (which these curators presumably know very well), the AGO hired celebrity thinkers from abroad to mimic a curatorial role, producing videos and a highly coded and instructional exhibition design to suggest how and why to look at art. In his long, WASPy didactic for Warhol's *Elvis I & II*, de Botton sounds very much like a parish priest or curate, proclaiming that 'Elvis stands for something that can go very badly wrong around money' and that perhaps less money, which forces us to 'save up,' 'choose carefully' and 'learn from [our] mistakes,' is better than too much. (Like most of de Botton's art interpretations, it's bafflingly off, for Warhol's depiction is of a young Elvis, likely from a publicity still for the Western *Flaming Star*, and so instead of thinking of fat Elvis, 'we' would

probably instead think of 'Love Me Tender' Elvis, of birth-of-rock-'n'-roll Elvis, of teen-idol Elvis.) In the fall of 2015, actor-comedian Steve Martin will open a co-curated exhibition of paintings by key Group of Seven member Lawren Harris at the Hammer Museum in Los Angeles, later set to tour to the AGO. Martin collects Harris, whose modernist landscapes are virtually unknown outside Canada (but quite well-known within it). Martin's celebrity is no doubt a boon to the exhibition's potential success at the AGO, as well as to the worth of the Harris estate.

In 2014, musician Pharrell Williams co-curated This Is Not a Toy, an exhibition for Toronto's Design Exchange that positioned designer toys (a.k.a. urban-vinyl art) as fine art. Pharrell's participation suggested the Design Exchange's commitment to drawing audiences, and indeed to collaborating with them, arguably in the manner of conceptualist or relational art. The very premise of the exhibition was, after all, to elevate ostensibly non-art objects into art, and this was done through a wilfully and garishly curated exhibition. Aside from Pharrell, who provided the value of celebrity, the design of This Is Not a Toy was integral. One commenter on designboom.com made the observation that the motifs on walls and plinths echoed certain conceptualists, with one monochromatic vertical-stripe motif reminiscent of Daniel Buren, and another diamond motif reminiscent of Frank Stella. At the same time as This Is Not a Toy, Pharrell collaborated with successful French gallerist Emmanuel Perrotin on a show for the latter's new space in a former ballroom in the Marais district of Paris. Entitled G I R L, after Pharrell's latest album, the show had Perrotin's roster of celebrity artists – Takashi Murakami, KAWS and Rob Pruitt among them – make work specifically inspired either by Pharrell or by his loose album themes of 'women' and 'love.' One could easily compare this blatant cross-promotional gesture with the subtler work of

the art world's star curators, who both commission work on specific themes and corral artists of similar sensibilities, seeming to make them over in their own images.

Artist-curators have also emerged as new phenomena in the curationist era, although of course they're not new. As we have seen, artists were the first curators in the contemporary vein, taking charge of their own work for aesthetic, commercial, even political purposes. The conceptualist moment saw an overlapping and confusion of roles of artist and curator, a template that persists to the present day, with many in the visual arts calling themselves by both (and other) titles. (The aforementioned Thomas Demand is a leading example of artist-curator and is plainly the best curator of his own work.)

New, however, is the institutional enlistment of artists, where artists are invited by the institution to curate, in the hope that their celebrity status and/or affiliation with creative communities will aid institutional visibility. In fall 2013, the Canadian art world was shocked by the appointment of artist Paul Butler as curator of contemporary art at the Winnipeg Art Gallery, because he had been known primarily as an artist, and his curatorial work, which he didn't to that point define as such, seemed loose, unprofessional. Butler is best known for hosting 'collage parties,' which he has done internationally (and are exactly what they sound like). He also ran Other Gallery, 'a nomadic commercial gallery [focusing] on introducing overlooked and emerging canadian artists to an international audience.' After a call for applications and about a dozen interviews, WAG director Stephen Borys had not found the right candidate, so, in a casual meeting with Butler, proposed the position to him. 'I wasn't hired to be a traditional curator,' Butler said at a talk at Toronto's Drake Hotel in November 2013, ten months after his appointment. 'I never considered myself a curator, even when they handed me the box of business cards with my title on it.'

The WAG's press release pertaining to Butler's appointment makes the curationist intention of the hire clear, quoting Borys as saying, 'As a practicing artist with diverse curatorial and exhibition experience, [Butler] offers a fresh perspective on the contemporary art collection and programming at the WAG, which is one of our priorities going forward. And the fact that he has an excellent network of colleagues and supporters on the local and national arts scene is a big plus.' Butler had not just been hired, but had been curated by the WAG, with audience-building and artist outreach top of mind. In July 2014, a mere sixteen months after his appointment, Butler resigned, evincing a divide, which I will discuss shortly, between the project-management drudgery faced by most curators and the alluring, breezy creativity of their star counterparts. 'I realized that I'm an artist who sometimes curates,' he told *Canadian Art*'s Leah Sandals in an online interview, 'and not an institutional curator.'

New York–based artist Kara Walker, best known for her unsettling silhouettes exploring iconography of U.S. slavery and segregation, was, in 2014, the third invited artist in the Katherine Stein Sachs and Keith L. Sachs Guest Curator Program at Philadelphia's Institute of Contemporary Art, which recruits artists as curators for exhibitions every three or four years. In response, Walker presented the group show Ruffneck Constructivists, a title that, according to the ICA's exhibition statement, references both the Russian constructivists (modern exhibition-design innovators through El Lissitzky and others) and the Italian futurists and their 1909 manifesto, an impish heralding, as we have seen, of newness and thus one of the key articulators of the avant-garde ethos that birthed curationism. Modernism was in fact evoked everywhere in the show. Included, for instance, was Johannesburg artist Kendell Geers' *Stripped Bare*, a play on Duchamp's sculpture *The Bride Stripped Bare by Her Bachelors, Even*, which Duchamp declared

finished when its glass was cracked in transport. In Geers'
piece, holes in two panes of glass suggest bullet marks from a
drive-by shooting.

Although the politics of the exhibition were, in Walker's
words, only a 'background hum,' one can see Walker's enlist-
ment by the ICA as an expression of the ways in which insti-
tutions recruit artists to impart not just the value of celebrity,
but the value of opposition. As an artist and woman of colour,
Walker is in a unique position to do what she did – to engage
in a curatorial project for which many in the curatorial field
(which is largely white and middle-class) would be criticized.
Walker's coup with Ruffneck Constructivists was staging her
own, ironic and arguably scathing version of curator porn,
going back to the first artist exhibitions to activate a clever
meta-institutional critique.

It is noteworthy to reiterate that curated group shows
around race and ethnicity have been a strong facet of the cura-
tionist moment since the 1990s, and constitute attempts to
court new demographics and add value to the institution as a
progressive and accepting entity. Artist Adrian Piper brought
this to light with her refusal to participate in the Grey Art
Gallery at New York University's 2013 Radical Presence show,
focused on 'black performance.' Piper asked instead to be
included in a 'multi-ethnic' exhibition about performance art,
and told National Public Radio that she no longer allows her
work to be a part of 'all-black shows.' A year before Radical
Presence, Piper humorously and cuttingly announced on her
website that she would not be curated for her race, turning her
back on the ghettoizing effects of this curatorial version of affir-
mative action: 'Adrian Piper has decided to retire from being
black. In the future, for professional utility, you may wish to
refer to her as The Artist Formerly Known as African-American.'

Corporations have long taken similar approaches to art
and creativity and their cultivation, all ways of signifying

humane, open and philanthropic business practices. The aim of corporate collections is not investment – art is a notoriously dicey way to increase short-term wealth – but outreach and public profile. Banks in particular are now prolifically collecting art. This can be traced back to David Rockefeller, youngest son of John D. and Abby Rockefeller, the former responsible for the MoMA's Cloisters branch of medieval art in North Harlem, the latter instrumental in founding MoMA. David Rockefeller, who has long refused the title 'collector' for himself, is the pioneer of corporate collections, and consulted art historians in the building of the vast collection of Chase Manhattan Bank in the 1950s, famously decorating its headquarters with the abstract expressionists, collected by his brother, Nelson. (Viewers of *Mad Men* will notice a parallel with the character Bert Cooper, who has a Mark Rothko hanging in his office.) It is no coincidence that bank engagement with art runs parallel to modernist exhibition practices and, then, the rise of the contemporary curator. Mid-century America was expert at conflating the avant-garde motivations of finance and art.

Today it is Deutsche Bank, not JP Morgan Chase, that has the largest collection of art, started in 1979 and boasting just shy of 60,000 objects. Like many bank collections, theirs has curators. Deutsche Bank's New York curator, Liz Christensen, began with them in 1994, in the first years of curationism. To listen to Christensen's job description, however, is to be reminded of the earliest curators, people like Robert Hooke of the Royal Academy and those responsible for the *Wunderkammers* or *Kunstkammers*. 'Here, every floor is furnished with a particular selection of art, and very different people have to live with it,' she told Deutsche Bank's art magazine in 2003, of the bank's New York headquarters. 'I play the role of a bridge – between contemporary art, which can be difficult and sometimes even somewhat prickly – and the "everyday" people

who work here, whether they're guests or employees. We offer tours, and we have an internal website profiling the works exhibited in the Lobby Gallery or in the collection. For us, it's simply a part of our job to impart a knowledge and understanding of art to our staff.'

Christensen's role is a common one in many banks, and although she distinguishes the curatorial exigencies of a bank from those of a private collection, these latter entities, too, boast curators who not only manage and acquire (again, in the vein of centuries-old curators), but who also lend significant value through exhibitions and, frankly, status. Multimillionaire U.K. property developer David Roberts, for instance, has enlisted influential contemporary-art curators, such as Parisian Vincent Honoré, to manage and exhibit the many works in his collection.

Increasingly, institutions are working without curators, yet still promulgating curatorial agendas. That is, their exhibitions *look* curated, but in fact no professional curators have been involved in the selection and arrangement of works. (The very slipperiness of what it actually means to be a professional curator is no doubt part of this.) This is the logical extension of touting celebrity curators like Alain de Botton, Pharrell Williams, Steve Martin, Katy Perry and Miley Cyrus instead of their institutional counterparts. (One might add that star institutional counterparts like Obrist and Biesenbach, with their project-managing personnel, are not, in certain lights, dissimilar in practice from these dabblers.) If curating curators is part of the curationist moment, then, equally, curating without curators is as well. In late curationism, it is the signification of having curated, an unmistakable cultural fetish, that matters. A curator proper need not necessarily be involved.

Bank of America's collection, unlike Deutsche Bank's, touts not curators but exhibitions. Their collection is so vast that

they have had it project-managed into touring exhibitions, featured on their website on a pick-and-choose page reminiscent of subscription-service companies like Trunk Club and Birchbox, who send clients 'curated' lifestyle boxes containing clothing, makeup and other items each month through the mail. The exhibitions are also reminiscent of those of New York–based non-profit group Independent Curators International (ICI), which, since the late 1970s, has generated more than a hundred exhibitions to tour internationally, in a brazen packaging and bureaucratization of the activities of freelance curators.

Which exhibition would you like from Bank of America? A beautiful selection of the art books of Henri Matisse? Or perhaps Andy Warhol Portfolios: Life & Legends is more your style. Do you fancy photography? It's our specialty; choose from Ansel Adams, Julie Moos and many others. Touring exhibitions are, of course, cost-cutting initiatives, part of the audience-oriented museum shift of the 1990s. Staffs and resources are being scaled back, and readymade exhibitions can offer works and time savings unavailable to institutions otherwise. (They are also, often, populist and an easier draw; the same phenomenon is occurring in the theatre world, with endlessly touring productions of major Broadway successes like *War Horse* or chestnuts like *Cats* trumping locally produced work.) Bank of America, whose shows have been taken on by the Bronx Museum, the Tucson Museum of Art and many others, even waives shipping fees. A 2009 article in the *New York Times* indicated there was a waiting list for these exhibitions. It is up to the hosting institution to involve their own curators, although in the *Times* article, the Guggenheim speaks out against such shows because, according to its director, Richard Armstrong, 'the reason the museum exists is to make exhibitions on its own.' More and more, however, this seems an antiquated philosophy (though not surprising coming from

the modernist bastion that is the Guggenheim). Unlike ICI, Bank of America certainly lists no in-house curators on its exhibitions page.

Bank of America is not alone in leaving out curators while curating. Some corporations, who in the 1990s would have pursued curators to manage their collections, are doing it on their own. Alden Hadwen, Director, Community Engagement, at AIMIA, a global loyalty management company, recruited the company's own staff to choose a significant portion of the works in their Montreal offices. PDFs were circulated, and although some curators were brought in to emphasize partic- ularities of the works to the staff – essentially to give provisos about technical elements that may not have been readily apparent in a digital document – the choice was ultimately up to them. Hadwen had trained the AIMIA staff to be cura- tors, in many respects echoing the utopianism of someone like Obrist or of relational aesthetics, albeit in a human- resources manner, celebrating the agency and quality of life promised by curated spaces.

Increasingly, high-profile commercial galleries like Gagosian and David Zwirner are mounting museum-style shows in museum-sized spaces with no ostensible curator- auteur. Zwirner's two gorgeous spaces that opened in 2013, on 20th Street in New York's Chelsea district and on Grafton Street in London, England, are reminiscent of small *kunsthalles*. Directors rather than curators are involved in mounting the shows, and they work closely with the artists, eventually receiving the input of Zwirner himself. Many commercial gallery shows, especially in New York and London (where Charles Saatchi arguably set the precedent), are now ambi- tious, sophisticated and researched, but there is no 'curated by,' no name – just the signification of curation (plinths, vitrines, precisely mapped out and arranged works, impeccable selection, vast amounts of white space). The value imparted

by curating, the aura of curation, is now undoubtedly possible without the curator.

Naoshima Island and its surroundings, notably Teshima and Inujima islands, located in Japan's Seto Inland Sea, are stunning, large-scale examples of late curationism, of curating without curators. The islands are sparsely populated, known both for their unique fishing-village culture, including a vernacular architecture that inventively employs smoked cedar, and for their wildlife (the islands were the first national park to be designated in Japan, in 1934). The area was transformed by post-Edo industrialization, turning it into a hub for refineries, which, especially in Teshima in the 1970s, polluted sea and air with emissions and dumping. While the nearby city of Okayama thrived, the islands, with their centuries-old traditions and precious ecology, were falling away. At the same time, Naoshima, home to copper refineries, became depressed due to the sourcing of cheap copper from the U.S.

Several factors have made the Seto Inland Sea what it is today, where few superficial traces of its industrial and economic devastation remain. Due to an impressive, inspiring and decades-long backlash by the residents on these islands, who number only in the thousands, Naoshima had become an 'eco-town' by the 2000s; its north, once home to Mitsubishi and its affiliate copper refineries, was now a treatment plant for industrial waste. In south Naoshima, droves of tourists, from Japan and elsewhere, arrive daily from the ferry docks at Okayama, about an hour away. A large, spotted-red pumpkin sculpture by Japanese artist Yayoi Kusama sits goofily on the coastline, greeting visitors who, on disembarking, are eager to have their photos taken with it. (Islanders as well as tourists are fond of Kusama's pumpkins, both this and another, yellow one located elsewhere. Houses display polka-dotted gourds at their entranceways, paying tribute to it, and it is rumoured

that when one of the pumpkins fell into the sea during a typhoon, fishermen rushed to rescue it.)

Kusama's winsome pumpkins are only a small part of a large project. Naoshima, Teshima and Inujima have become art islands or, to use a phrase cropping up more and more in the art world, art-tourism destinations. This is largely the doing of language-training publishing mogul Tetsuhiko Fukutake, director and chair of Benesse Holdings Inc. and chair of Fukutake Foundation. Fukutake's speech at the Setouchi International Symposium in 2010, excerpted in press materials for Naoshima, expresses a utopian and social belief in the transformative power of art that is resonant with the art world's most prominent curators, particularly in the context of biennials. Fukutake, in fact, began the Naoshima art site in 1989 with the unveiling of the Naoshima International Camp, in effect a participatory-art project. Here, visitors were encouraged to 'experience the natural landscape' of south Naoshima by staying overnight in pristine-white Mongolian yurts on exquisitely designed grounds by starchitect Tadao Ando. That year, Naoshima's first public sculpture was unveiled, Karel Appel's *Frog and Cat*.

In Fukutake's speech, he stresses the concept of a 'happy community':

Many people around the world still believe that there is no utopia in our world and that they will find it in heaven or paradise after they die. Can this really be true, when there is no one back from the other world saying that paradise there was wonderful? After seeing the elderly people in Naoshima become rejuvenated by cheerfully interacting with contemporary art and young visitors to the island, I decided to define a happy community as one that is 'filled with the smiles of elderly people who are our mentors in life experiences'...

I believe that Naoshima is thus the happiest community in the world and attracts many visitors from overseas… I believe contemporary art has the great potential to awaken people and change a community.

Of course, *benesse*, its Latin etymology commonly expressed in many romantic languages, means *blessing* or *gift*. The Fukutake Foundation and Benesse Holdings have interpreted it as *living well*.

I visited Naoshima in October 2013 and can attest to its intoxicating, paradisiacal qualities. The natural landscape alone is worth the pilgrimage, but each art site initiated by Fukutake since that first campsite in 1989 can, in the manner of the island's alluring vernacular architecture, boast a seemingly perfect integration with that landscape. It is as if contemporary art now grows out of Naoshima.

Devotees of Tadao Ando will find much of his important work here. He is a brilliant fit, known for integrative minimalist architecture in the great Japanese tradition, with stress on structural integrity; clean, geometric spaces that work with light as a design element; and hard, simple construction elements like stone and concrete. Ando's three standout constructions are the Benesse House Museum and the Benesse House Oval, which houses a hotel and restaurant amid a display of works from Fukutake's impressive Benesse collection. Constructed on a cliff, it has several terraces providing sublimely constructed views of the coast, from which one can look in any direction and see dreamy vignettes of nature intersecting with Ando's clean, canted lines. Ando's Lee Ufan Museum, a home for works by the Korean minimalist with whom he shares aesthetic affinities, dips down onto a spare field, its entrance a staircase next to a formidably high concrete wall. Ando's Chichu Art Museum goes underground, a cold vault that displays only three works: selections from Claude

Monet's *Water Lilies* series; a light piece by James Turrell, who has another work on Naoshima; and a dramatic space designed by Walter De Maria that looks like something out of *2001: A Space Odyssey.*

The constructions on Naoshima have a quiet elegance that belies their complexity. De Maria's work at the Chichu in part consists of a giant, polished, granite ball, which sits halfway up a staircase surrounded on both sides by long gilded-wood geometric forms. Elsewhere on Naoshima, Hiroshi Sugimoto's *Go'o Shrine* from 2002 updates an old Shinto-Buddhist shrine from the Edo period, its altar, in Sugimoto's retooling, a glass staircase going down into an underground stone chamber, accessible via a long corridor that, when one reaches the end, provides a reflective view of the inland sea resembling one of Sugimoto's spare, melancholy black-and-white photographs.

Exhausted from such beauty, I and several international journalists brought to Naoshima by the Japan Foundation were, after a perfect (curated?) lunch at the Benesse restaurant, brought to a conference room where we were given a detailed presentation on the activities of the Fukutake Foundation and Benesse Holdings. Impressed and slightly overwhelmed, I asked the presenter if there were any curators involved in any of the island's projects. Surely, given the consistency of vision and the impeccable installation, there was a behind-the-scenes curatorial team cultivating everything. My question was translated but the presenter seemed flummoxed. After a pause he said, 'We hope Mr. Fukutake lives a very, very long time.'

Evidently Naoshima represents the directed vision of one person fanned out, notably with the aid of Ando, into manicured reality. Naoshima (unfortunately our tour did not include Teshima) seemed a wonderland, but one in which aggressively finessed value was the lure. Naoshima may attract tourists from nearby Okayama, but it can be expensive for Japanese to travel even within their own country. For others not in

Japan, Naoshima, while not itself curated per se, becomes part of a curated, luxe lifestyle. 'Have you seen it at Naoshima?' may have been on the tongues of collectors who visited alternate, expensive versions of Kusama's pumpkins at Art Basel Miami Beach in 2013 and Frieze New York in 2014.

The aura of the curated is not only expressed in the remote Seto Inland Sea. Today we see it, for instance, in most of our retail experiences, in which we are presented with a total experience, a selection of curated items, the organization of which, again implicitly inspired by Barr's Useful Objects shows, constituting an amplification of their value, along with that of the brand presenting them. Popular American grocery-store chains Whole Foods and Trader Joe's are obvious examples of the aura of the curated in the everyday, where, merely by walking in the door, you are promised access to certain foods and not to others, as well as to a certain style, which comprises packaging design, store geography and staffer personality. It is not this book's intention, nor within its scope, to enumerate all expressions of curated auras in the retail world and daily life. Doubtless you are aware they exist (IKEA, Pottery Barn, Restoration Hardware, Uniqlo, Uline, the list goes on). Less evident is the work, yours and others, that rationalizes their existence. Value, as regards connoisseurship, selection and promotion, is one thing. Work, the execution and fostering of such value-based visions, is another.

Thus far our story of curationism has centred on value: how the inherent novelties of the avant-garde, under the translating influence of the curator (or, later, something like the curator), became assets. A contrarian, insouciant and critical attitude toward work is also essential to the avant-garde's value imparting, and we have certainly seen this not only in radical artists but also in star curators and dilettante celebrity curators, whose 'labour' over the choices they make for a variety of exhibitions and product lines can seem either dubious or overarticulated. Musician Santigold's 2014 collaboration with Stance Socks, to whom she provided three patterns is, for instance, described in elaborate terms in the press release:

> Carefully curating this three piece collection of one-of-a-kind socks – Santigold spent the last year creating designs stimulated by music, travel and more. The new collection includes three unique socks titled Brooklyn Go Hard, Gold Links and Kilimanjaro. Santi…found inspiration from her trip to Tanzania where she climbed Kilimanjaro as part of a documentary to raise awareness for the global clean water crisis. Her visit to a Masai village during this trip influenced the mix and match pattern found on her Kilimanjaro sock.

Sometimes you have to climb a mountain to properly curate a sock.

Let us return to the art world. What allies contemporary star curators with the kind of eminent artists they promote is not just strong institutional affiliation and sensitization to audiences. Both factions are also committed to what is known in art-theoretical circles as 'deskilling': they make livings doing

things many would deem the antithesis of work. The pioneering art-world instance of this is Duchamp's urinal, its presence in the gallery transforming it into a multiply valuable thing. (Indeed, the current art-market value for one of Duchamp's urinals is more than US$3 million.)

Outside of the idea – the generation of which, naturally, any conceptualist would cite as vital labour – Duchamp did no crafting on the urinal other than turning it upside down and signing it with a pseudonym, 'R. Mutt.' This unusual commitment to deskilling would prove hugely influential to the art of the 1960s and 1970s, which we have discussed only in the context of value and its reinvention and reinstatement by the curator. It is thus important to note additionally that, for instance, releasing gases into the air, as Robert Barry did, or masturbating underneath a raised gallery floor, as performance artist Vito Acconci did, is not what most would consider 'real' work. This was especially true in the 1960s and 1970s, when the traumatized, nose-to-the-grindstone Greatest Generation – a.k.a. those who came of age in Europe and North America during World War II and gave birth to the baby boomers – still dominated the labour force. At the same time, it is also important to restate that, while reprehensible to some, deskilled art, since the mid-1990s and its banner movement, relational aesthetics, has been vital to institutions' courting of audiences, because it tends to welcome just as many as it alienates. Building on German artist Joseph Beuys' famous statement 'Every human being is an artist,' institutions empower and attract viewers through open, democratic notions of creating. 'My kid can do that' has in many senses transformed from dismissal to marketing opportunity. Most major institutions now have activity spaces for children that arguably reflect the ideals of relational aesthetics. Rirkirt Tarivanija, also a curator, is most famous for cooking Thai food and then doling it out to onlookers in galleries and museums.

Cooking is no doubt a skill, but a domestic, not a rarified, one. Its function and presence, however gloriously synaesthetic, is widespread. (Ironically, the best-known definition of *deskilling*, understood in particular by economists, does not carry with it this connotation of heroism and democracy. Rather, it means the cost-cutting phasing-out of professional workers by machines or less-skilled workers. As we have seen with dilettante curators in the last chapter, and as we shall subsequently see with the extension of curatorial work into daily lives, the art-world meaning of *deskill* is, more and more, resembling this more common, bleaker one.)

It is worthwhile to hark back to Obrist and his aggressive, paranoid commitment to defining his curatorial work as labour and to branding himself as hyper-industrial. Part of that first cohort of contemporary curators who lent value not only to audience-oriented work in the context of the institution, but also to themselves, to the very idea of the contemporary curator as an employed, salaried entity, Obrist was an innovator. To some curators, this makes him heroic. His conscious industriousness functions as a plea. The curator's quest to engage in a practice of connoisseurship, of thinking and arranging, and to be paid for it, sits alongside the conceptual artist's fraught efforts at same. How, for instance, do performance artists practice what they do? What do they need studios for? For some this is irrelevant, even offensive: the whole point is that conceptualist practice lies outside of traditional capitalist imperatives. For others, articulating performance art as an unexpected form of work is a way of advocating for it.

For, say, Marina Abramović, who has established an Institute to catalogue and promote her life's work, such things are central. Ironically, both Abramović and Obrist have been vilified as effective bosses. Abramović was criticized in 2011 for hiring and underpaying performance artists to execute one of her pieces at a Los Angeles MOCA benefit. Performance artist

Yvonne Rainer dramatically called Abramović's harrowing, durational job description 'reminiscent of *Salo*, Pasolini's controversial film of 1975 that dealt with sadism and sexual abuse of a group of adolescents at the hands of a bunch of post-war fascists.' In 2014, Abramović met with further criticism after her institute posted four 'volunteer' positions that clearly required specialized training. Obrist and Julia Peyton-Jones were chastised in December 2013 for each taking, in the vein of egregious post-recession American CEOs, 45 percent pay increases at the Serpentine.

Enter the notion of professionalism, a defining aspect of the art world since the curator emerged as institutional powerhouse in the mid-1990s. Funding cuts to the arts affected not just museums and galleries, but academic institutions as well. These institutions did, in many respects, what museums and galleries did. They aggressively courted audiences, in this case donors and students. In North America, critical theory imported from Europe, mainly from France, became trendy in the 1980s and effectively colonized universities in the 1990s, allowing graduates of various humanities departments to specialize, and thus to brand themselves and gain professional toeholds in highly specific, unprecedented ways. Current academic specialists in such subjects as 'ecocriticism' and 'homosociality' were certainly unheard of before this period.

Since one of the main objectives of critical theory, particularly of poststructuralism, is to explode assumptions about and thereby expand notions of and inquiries into language, tradition and privilege, the academic embrace of critical theory, despite inevitable resistance from tenured traditionalists, acted as an ideal outreach method. Academic staffs, like curatorial staffs, duly expanded. New, genial- and sexy-sounding departments and programs emerged, such as urban studies, cultural studies and gender studies. Detractors called them 'boutique programs.' For many this signalled something positive, as it

did for museums and galleries embracing contemporary curators in the Szeemannesque mode: institutions were ostensibly newly welcoming, breaking free from stodgy, dead-white-male–focused curricula. More than this, they were applying avant-garde pedagogical approaches. That the avant-garde, as I have argued repeatedly, is intimately tied to capitalist practice, that its cycle of novelties creates its own fetishes, hierarchies and star systems (star academics have much in common with star curators), was, during these salad days of contemporary academe, faintly acknowledged, if at all.

It is unsurprising, then, that 1990s fine-arts and art-history departments, during a time in which the very idea of history, like the canon, was under intense scrutiny as subjective, oppressive, even obsolete, felt extreme pressure to diversify. The institutionalization of once-iconoclastic practices meant artists were under parallel pressures to professionalize by taking graduate degrees. MFA programs, in the past adopted by only a handful of artists, became popular, especially for those working outside painting, drawing and traditional sculpture. One could now do a master's degree in new media or performance, something that, while not guaranteeing success, offered promises of theoretical grounding, opportunities to experiment and grow, and chances to convene with peers and to network. In the 1970s, experimental fine-arts programs at places like CalArts in Los Angeles or NSCAD in Halifax were – however subsequently influential – nascent and exceptional. By the mid-1990s, it was ironically clear that conceptualist practice in particular was readily abetted by such academic training – given, for one, obvious overlaps between those working in institutions and those working in academe. (Among other things, many universities established art galleries, or renovated existing ones, during this time.) Artists were learning to curate their own educations, and thereby to make themselves amenable to curators. Multiple degrees became a

way to materialize oneself and one's work. Today, an MFA is an imperative for a contemporary artist. Because of this, doctoral programs in fine arts are now emerging to trump master's programs, further professionalizing a field that many thought could not be professionalized any further.

While fine-arts graduate programs have been triumphant, curatorial-studies programs have had mixed results, although their expansion since the 1990s is notable, on par with that of biennials – coming, as they do, from the same curationist impetus. Many curatorial-studies programs are, in fact, reminiscent of Manifesta (or Naoshima) in their lavish commitments to utopianism. This is not unrelated to the important fact that the first cohort of contemporary curators – Hopps, Szeemann, Lippard, Siegelaub et al. – were not, on the whole, formally trained, possessing disparate expertises in a variety of humanities and non-humanities fields, many not art historical (a subject/department that, as opposed to curatorial studies, has been a time-honoured facet of most humanities programs). While the second, mid-1990s cohort of curators, by virtue of the socio-economics of their generation, possess more credentials, they skew toward the multidisciplinary, even the motley. Okwui Enwezor and Christov-Bakargiev emphasized poetry in their educations; Hoffmann, like Szeemann, is trained in theatre and dramaturgy; German curator Nicolaus Schafhausen began as an artist; Gioni (who did a stint as an editor for *Flash Art*) and Obrist began as relative outsiders and essentially progressed by forging key art-world relationships.

So it was that many notable curatorial-studies programs were initiated in the think-tank or symposium model, multidisciplinary dream spaces reflecting contemporary curating's fanciful everywhereness, and in which aspiring curators could develop their own theoretical or conceptual groundings while communing with groups of similarly aspiring students to,

ultimately, devise some sort of exhibition or exhibition proposal as a final project reflecting their experience.

In a 2008 essay in the anthology *Raising Frankenstein: Curatorial Education and its Discontents*, Teresa Gleadowe, instigator and director of the pioneering curatorial-studies master's program at London's Royal College of Art from 1992 to 2006, logically positions the emergence of the first curatorial-studies programs alongside 1960s and 1970s conceptualism. In her mind, both are 'rooted in these years of artistic and institutional upheaval.' 'Until [the 1980s],' she writes, 'curating had been something one learned, over time, on the job.' (This is unquestionably true of many cultural professions previously requiring only general knowledge of the humanities, such as journalism.) Gleadowe goes on to itemize the linchpin curatorial-studies programs that stressed this conceptual approach: École du Magasin in Grenoble, France, founded in 1987; the Whitney Independent Study Program in New York, in existence since 1968 but revamped as Curatorial and Critical Studies by *October* magazine critic Hal Foster; the Center for Curatorial Studies at Bard College in Annandale-on-Hudson, New York, founded in 1990 with the crucial aid of collector Marieluise Hessel; and de Appel in Amsterdam, dating from 1994.

Gleadowe's curatorial-studies utopia, like Manifesta's, is a definitive no place/everyplace. In a contention that embodies the philosophy behind many curatorial-studies programs, she writes that learning 'on the job' is not ideal, and prone to staid rhythms:

> [It] implies the absorption, over time, of a set of established behaviours, based on tried and tested practices and precedents. Such learning also tends to 'normalize' established practice; it treats all procedures as part of the *common speech* of exhibition making. By emphasizing routines, it minimizes the decision-making involved

in each action, the extent to which every decision 'performs' certain values and belief systems, certain assumptions about whom the exhibition is for (who is being addressed) and why (for what purpose) the exhibition is being made.

Gleadowe quotes MoMA curator Stuart Comer's view that programs like the Whitney Independent Study Program foster 'the construction and maintenance of a critical space resistant to both academic and artistic professionalisation.' The world's largest and most prestigious curatorial-studies schools are thus, for Gleadowe, not part of the professionalization of the art world; they are the opposite, resistant to professionalization. Notably, the argument speaks to the classical purposes of humanities learning – that it must be somewhat divorced from usefulness, and not quantified for its practicality alone.

Gleadowe's argument about curatorial-studies programs is perfectly in line with what we have already seen from contemporary curators. The curator's deprofessionalization is effected by the creation of programs ostensibly designed to support this deprofessionalization, but which ultimately result in (re)professionalization. Utopia again curdles into dystopia. Gleadowe's is a textbook tautology: a deskilled approach to work is fostered through a bureaucratic framework, however radical in intention. If her idea of curatorial-studies programs holds water, one wonders why one would take a curatorial-studies degree and not, say, a bachelor's or MA or MFA. The very existence of curatorial-studies programs – and they continue to proliferate – suggests not only that contemporary curating is a learned profession with its own specificities, but also that curating has become an expanded field in the job market. If Gleadowe is implying that a curatorial-studies degree complements a bachelor's or master's degree, she is abetting a credentialist view of the curator,

which itself goes against her advocating for the deskilled essence of the job.

The real-life parameters of the 'job' are, actually, often ignored when one discusses contemporary curating as a blue-sky vocation only, a discussion that homes in on, as I have done thus far, star curators and the alluring world of ideas, artists and international events they inhabit. A star curator, who in the 2010s is often also a gallery or museum director, is – like the executive director or CEO of a company – responsible for big-picture visioning. They oversee the years-ahead itinerary of a major institution; they massage the logistics of a major exhibition, such as a biennial, that may not be conventionally situated; they green-light a set of major performances and artworks for an exhibition based on budget projections, continuing to vet expenses as they come up; they liaise with important donors and collectors, in concert with artists and galleries, to facilitate the loan, purchase or donation of artworks to an institution's collection, or for an institution's exhibition; they give talks, regularly visit artists' studios (sometimes with collectors or donors in tow) and write about their and others' exhibitions for significant general and scholarly publications; they travel to exhibitions, fairs and symposia, filling ambassadorial roles and updating their knowledge of contemporary art in situ; and they shape the arrangement and content of their own and, sometimes, their colleagues' exhibitions. These star curators occupy a small percentage of working curators. Yet it may be this professional expression of curating whose needs are particularly met by Gleadowe's conception of curatorial-studies programs as, essentially, theory-heavy leadership-and-visioning seminars.

What do most contemporary-art curators actually *do*? Vancouver curator Karen Love produced a free online *Curatorial Toolkit* PDF in 2010, co-funded by the Province of British Columbia and the not-for-profit philanthropic organization Legacies Now, which, in the words of its website, 'leveraged the 2010

Olympic and Paralympic Winter Games to create social and economic benefits in communities throughout British Columbia.' The *Toolkit* acts as a useful piece of anti-glamour, showing just how mundane contemporary curating can be. Love stresses curating as, yes, a 'real job,' not an unconventional, deskilled one, but one whose skill set would require some vocational training, whether on-the-job or from an internship or practicum. The lack of such vocational training in some curatorial-studies programs is why Love's document exists, in addition to its desire to articulate standard, best-practice freelance-curatorial fees, which can vary wildly and tend to be low.

Love's document presents a vision of curators as project managers. The tasks it outlines are many. As a publicly funded document, it is focused on freelance curators working for publicly funded entities, that is, artist-run centres, where budgets and staffs are limited. Love's tasks can, however, be applied to larger museums and galleries, but here they are likely to be delegated to a team (although, as arts-funding cuts persist, such teams continue to shrink in number).

Love breaks down the on-the-ground practice of putting on a show into several steps. First is researching a concept, which requires having a strong sense of purpose and a strong knowledge base as a curator (this includes possessing a distinct sensibility, style or approach), selecting artists (this includes having established positive, respectful relationships with a variety of artists over time, probably through studio visits and consistent participation in the art scene), writing a proposal (for which Love activates the curator's classical affiliation with the avant-garde, noting 'a new curatorial presentation of the work can re-position artwork with a fresh perspective and context') and researching funding – especially granting – opportunities.

The next step is finding a venue, which includes taking into account location, space configuration and size, and

staffing and equipment resources, as well as pitching one's proposal to a gallery ('If the gallery declines the proposal, do not take it personally… Keep trying! Move on to the next venue on your list.').

Third, after venue confirmation, is paperwork concerning the logistics of the exhibition: a 'curator's contract' or letter of agreement stipulating information on curator and artist fees, cancellation terms and much more, as well as that staple activity of project managers, generating a 'critical path' for the exhibition in order to present a realistic, cogent timeline for all exhibition-related tasks to be completed. (Love's sample critical path makes sure to break down tasks between curator and gallery, as the latter, typically resource- and cash-strapped, can often compel the curator to take on the brunt of the workload.)

Next is 'completing the project concept and artist selection,' which 'may take many months.' Here, the curator, either formally or informally, asks artists' permissions for their work to be shown and embarks on the tricky, time-consuming process of loan requests, which 'need to be made to public institutions and corporate or individual collectors well in advance (most institutions require a minimum of six to twelve months notice)' and for which the curator 'will need to outline [the artist's] credentials, in addition to the project's intent.' Elements for the curator to consider include insurance rates on the loan item, crating and framing costs, security required for the work in the exhibition space, transportation expenses that will be incurred, handling fees and reproduction fees, if any. At the end of this step, the curator should generate a master list of works for the show; Love suggests making a chart keeping track of things such as insurance value, loan-request approvals and credit information.

Then the curator begins with the specifics of budgeting, including enumerating artist fees, their own fees ('For a single-venue exhibition, the curatorial fee can start at $2,500 and

continue upwards to perhaps $15,000 or $20,000. It should be noted that the higher fees are less common and generally provided to well-established curators.'), fees for talks and various public programming, installation fees, costs of travel (including for their own research and to bring artists in to visit the show) and, of course, of installation, which can include architectural elements, the labour fees thereof and security. The curator follows by breaking down logistics and expense details from the master list of works for crating, shipping, insurance and customs brokerage, and also plans visual documentation for the show.

Finally, the curator completes paperwork for artists and potential grants, establishes a plan for outreach and public programming around the exhibition, and devises a media strategy for the show, everything from its design identity to reaching out to media in advance of the opening.

Regarding the mounting of the show, Love notes that 'the curator will not be responsible directly for all tasks related to the installation' but, again like a project manager, 'is responsible for ensuring that the work, and the exhibition itself, is presented to the best of everyone's abilities and in a manner that is beneficial for the artists and for each work of art.' Attention to detail is key. Curators must troubleshoot installation needs and be present during installation, carefully supervising the mounting of works based on detailed exhibition plans and the (often demanding and persnickety) requests of artists. The process can be exhausting. Love notes that 'long hours of work may be required. A positive problem-solving approach, determination and humour, and sometimes a boost of adrenalin, are required!'

As with any project that has taken a long time to complete, alterations and augmentations often occur mere seconds before the opening. The behind-the-scenes frenzy of the art world has not been romanticized or even widely acknowledged as it

has been in, say, the dance and theatre worlds, in which the harried, bellowing director/impresario is an archetype, immortalized in such films as Lloyd Bacon and Busby Berkeley's *42nd Street* and Michael Powell and Emeric Pressburger's *The Red Shoes*, or in the fashion world, in which pre-runway chaos is, for non-industry types, full of sexiness and mystique. It was my intention to shadow and then report on the real-life installation circumstances of an exhibition for this book, but no curator I asked was comfortable with the request. The art world's positioning of the curator as a sleek, put-together spokesperson for exhibitions, and for contemporary art's triumphant relevance, is no doubt responsible for this conspicuous reticence.

The curator's job is not done after the opening, with final payments and accounting due, project assessments and reports (especially relevant in light of any grants received), the management of a publication if it has not already been produced, a show's de-installation, which can be just as complicated and stressful as the installation, and the prospect of an exhibition tour, which has its own set of concerns similar to those outlined above. The very exhaustiveness of Love's document suggests why touring exhibitions are becoming more and more popular for institutions, even artist-run centres: they come prepackaged, so the labour, notably the staffing, involved is not as intensive; there is a sharing of finances between or among institutions, lessening the significant cost burden that a completely new show would entail; and, once secured, they can be scheduled with relative swiftness and firmness, leaving an institutional curator, who more and more has very little time for field research, something with which to buy time and fulfill mandates.

Love is technical and largely partisan, though a portrait of the contemporary freelance curator emerges, and it is daunting and depressing: underpaid and working with limited budgets and time; lobbying for resources and wearing a number of hats

at once; to wit, exhausted and perhaps nearing extinction. With many institutions using what Love calls 'zero bottom line' budgets, in which potential revenues, including from shaky streams such as publications, are counted as expenses, freelance curators passionate about seeing their visions carried through often take money from their own fees to make their exhibitions a reality – even though Love, as an advocate for standardized fees (which are not, despite her and others' efforts, widespread in Canada and many other countries) strongly disapproves.

Do any prominent curatorial-studies programs offer training for what is articulated in Love's *Toolkit*, and do any, while doing so, prepare students for the rough road ahead? It is a difficult question to answer given all current programs' provenances in universities rather than in technical schools or vocational colleges. To reiterate, the humanities in universities have always been designed to be discourse generators and mind enhancers, not career-placement programs. So the short answer is *sort of*. There is a vocational element to most schools' programs, despite Gleadowe's theoretical objections. A cynic might say there has to be, in order to make the programs marketable. ccs Bard, for instance, gives a detailed rundown of its curriculum on its website, and it includes, as of 2014, twenty-four credits in ten required courses, four of which are practicums, and six a summer internship, meaning at least two hundred hours working under an 'arts professional.' A final project, in addition to a written thesis, includes a 'curated component,' some stipulations of which are 'budget' and 'installation plan.' Bard is also well-situated in Annandale-on-Hudson, a few hours by train from New York City, where, unsurprisingly, a number of field trips and internships take place.

There are problems with Bard's approach. Known for its rigour and theoretical grounding – its curriculum page articulates what it 'assumes' of a prospective student, and this includes knowledge of art history, cultural production, a broad

range of social and cultural histories, as well as a 'trained sensitivity' to 'aesthetic demands' – Bard still endorses Gleadowe's blue-sky notion of curatorial education. In a 2011 roundtable discussion on curatorial-studies programs published in *Frieze*, writer and curator Anthony Huberman, having done a few workshops at Bard, notes that 'many students' 'seem to reject' doing final projects tailored to 'the white cube.' This is no doubt due to what is written on Bard's curriculum page regarding the thesis proposal, and to its conceptualist and avant-garde underpinnings: 'Given the program's understanding that contemporary curatorial practice often engages with unconventional formats, this proposal may put forward an exhibition, book, symposium, online platform, or other project for consideration.' Huberman notes that 'what worried me…was the importance they gave to the form and structure of the exhibition. It's fine to experiment with form and structure, but not just for the sake of it… [A] show needs to start with the actual content of the art work and what it asks for. A show is interesting not because it experiments with form or structure, but because it finds ways to share the content of a work of art by creating an appropriate frame for that content.'

In a similar roundtable in *Raising Frankenstein*, Richard Flood, known for his curatorial work with New York's New Museum, calls the Marieluise Hessel Collection, around which the CCS is effectively built, an 'artificial wonderland.' Since the program's inception in the 1990s, students work with its artworks for various assignments and, Flood implies, are given a false sense of what they might have available in the field. Many of the works are, Flood quips, on permanent loan, meaning they 'can be removed at the drop of a hat.' Flood also finds Bard's focus on a collector's trove 'problematic…on the level of class.' 'It's probably been written about [i.e., cumulatively, by Bard students],' he says, 'more than any holdings of the Medici ever were.'

Bard's practical qualities might not be practical at all. The school stresses, in Huberman's view, an idiosyncratic, formal-experimentation-for-the-sake-of-formal-experimentation approach (i.e., a traditionally avant-garde one). And in Flood's view, it ironically abets the worth and visibility of a wealthy donor's collection (an element of museum and gallery work, to be sure) while at the same time emphasizing dense critical theory that ostensibly resists the roles class and money play in the art world. It is important to note that Bard's tuition is one of the highest for curatorial-studies programs, most of which come with standard (i.e., pretty high) fees for graduate humanities work. CCS Bard tuition for the 2013–14 academic year was $37,284. According to Bard's website, 'More than 90% of CCS Bard students receive some form of financial aid,' although it is also stated that 'most students' end up receiving funding covering between 25 and 40 percent of tuition, which, given base tuition, still leaves a significant debt load. It might also be pointed out that the de Appel Curatorial Training Programme in Amsterdam, known for its hands-on, vocation-ally driven approach, costs less than 3,000 euros to attend, but accepts only six students per year.

Pamela M. Lee, Art and Art History professor at Stanford University and author of numerous critical studies on late modernism and 1960s and 1970s conceptualism, affirms a view she expressed at the 2008 Contemporary Art Forum in Faenza, Italy: curatorial-studies programs are 'the world's most glam-orous vocational schools…but a cash cow to older and more established programs in art history.' She tells me, 'The vocational dimension of the curatorial program that I kind of tossed off in that statement addresses, in a band-aid-like way, the worry about what it is that one accomplishes when one gets a degree in art history or a related field, visual or cultural studies.'

This statement can be placed alongside the similar-in-tone Standards and Guidelines written by the U.S.'s College Art

Association, at which Gleadowe looks askance in her argument supporting deskilling in curatorial studies. Intended as a report, the CAA's entry on curatorial-studies programs is, by virtue of its practical focus, not rosy. 'Students and their advisors should be aware of the relatively small size of the art-museum universe,' it reads. '… In practical terms, this means that in order to find a position, one must be willing to relocate. Students should also be aware that starting curatorial salaries tend to be low, and advancement within an institution is not guaranteed.' The entry goes on to note that, for 'specialized curatorships' in large museums or director-curator jobs in 'smaller-city museums,' a PhD is quickly becoming the norm. (Many art-history doctoral programs offer the option to complete a certificate in curating, which covers vocational basics.) The irony is that the emergence of boutique programs like curatorial studies is a by-product of the same credentialism that now makes PhDs the increasing standard at museums.

'That a student who emerges from [a curatorial-studies] program might go on to become the next Hans Ulrich Obrist – this is of course a fantasy,' says Lee. Based in the Bay Area, Lee points to America's other major curatorial-studies school, San Francisco's California College of the Arts (CCA), which is known for and styles itself as, much more than Bard, a theory-over-practice program, with freelance curators as their ideal. Lee worries about the expectations of graduates. '[Obrist] is the exception to the vast numbers of students that are other-wise coming out of these programs. He is a model that is frankly unattainable now, precisely because of the profession-alization of these curatorial schools. He entered the stream when there was a lot more flexibility in terms of where one came from, how one approached these artists and what one's training was.'

Obrist represents the new feudalism emerging in culture work, in which a select deskilled few from older generations,

sometimes dubbed the 'curatorial class,' maintain their illustrious positions, leaving open scant vacancies, which, due to low pay and the education and internships now necessary to secure them, are accessible only to the very wealthy. This is already a caricature in the contemporary art world via the figure of the 'gallerina,' a young, typically female art-history, museum-studies or curatorial-studies degree-holder who serves as an intern or assistant in a commercial gallery, often for little or no pay, with the aspiration of institutional curatorial work or 'owning my own gallery someday.' Although there are few pop-cultural examples of the curator, there are plenty of the gallerina, including the character Marnie Michaels on the television show *Girls* and the cast of the Bravo reality-television show *Gallery Girls*.

'It's a knot tied around these enormous economic problems,' says Lee. 'Because one of the conversations I hear more and more frequently at Stanford does, in fact, have to do with internship culture, which then effectively becomes free labour on the part of the students who can afford it. I don't know if this is a particularly helpful comparison, but back in the day, when I was in undergrad, I took on internships at various museums and then found I had to take on a crazy work schedule to support these internships. That was certainly not ideal by any means, but by the same token I acknowledged that at least there was gainful employment to be had for my generation of student – a budding scholar, emerging curator, whoever.

'But now it's almost pro forma that you would expect to have these kinds of internships in order to further a career coming out of a curatorial-studies program. I think what's strange about that, though, is that historically the order seems to be flipped. In the past, to get into these kinds of master's programs you needed the internship. Now it seems the curatorial program is what gains you entry into the internship itself. That's troublesome because it simply defers the reality

that there are not enough positions to go around, unless you happen to be independently wealthy and can make your way in terms of [freelance] curating and so on. It's very troublesome; I think about art schools in particular, something like [CCA], and [wonder] where these students will end up.'

The advice Lee gives to a hopeful curator is the same advice many curators gave me concerning this question during research for this book: don't take a curatorial-studies degree, at least not right away. And if you do take one, use it as a professional-development tool rather than a vocational one. 'After you've got your BA, take time off and work in the art world,' recommends Lee. 'This might mean working in a gallery or museum – this is a real education in how things get done. Or even if you are an undergraduate and there aren't programs in your college or university, [try to do paid or unpaid work] at a museum or gallery close by.

'After you graduate, take time off and get some real professional understanding of what the art world consists of. This fantasy that you're going to go to an MA program and suddenly somehow understand the institutional culture of the art world is ridiculous. After you've had those couple of years in the trenches, go back to graduate school. And if you're really serious about being a curator – being a curator at the level that most people, I think, assume most curators operate – you will need to get an advanced degree.

'I think curating programs are like creative-writing or critical-studies programs,' Lee continues. 'If you can accept those programs in those terms, with limited expectations as to what the professional end will be, then you'll probably be in a far healthier position when you finish them. You do get a certain kind of experience which is wonderful, and I think that they have virtues as well as enormous liabilities.' Lee herself is a graduate of the Whitney Independent Study Program and says it is very successful because it is attached to

an actual institution. Lee also admits that, after learning the nuts-and-bolts of curating through the Whitney ISP, she ultimately discovered that she did not want to be a curator.

'At the level of the curatorial track," she says, "you do learn how to put on a show, which demands a certain baptism in the *realpolitik* of the museum world. You do get super, super practical experience. You learn about loan reports. You learn about presenting to a board. You learn all the stuff you'd need to know if you were functioning within a museum world. That means the tedium of all this bureaucratic stuff alongside the quote-unquote *fun* part of conceptualizing and meeting artists and putting the shows together.

'I would say that as a model that was very helpful, because you're getting both sides. The fact is that some curatorial-studies programs do have an element of learning something about the bricks-and-mortar foundation of how shows get put together – but I somehow don't think they get tied up in the really bureaucratic dimension of curating. Which is frankly huge. It's an enormous part of it.'

How much curatorial work did you do today? You got dressed, perhaps laying out various options in the manner of an installing curator. Perhaps, for lunch, you went to Chipotle, Subway, Teriyaki Experience or one of any number of food chains that now ask you to select ingredients to compose your meal. (Subway got in early on curationism, calling their sandwich-makers 'sandwich artists' in an amusing, telling marketing of the artist-curator relationship as parallel to that of the server-customer.) Perhaps you purchased something from an online retailer like Amazon or Everlane, consumer-curatorial work that will result in subsequent emails from the retailer suggesting other products you might like. Perhaps you updated your profile on a dating website or app, further stream-lining your identity to attract the right people and repel the

wrong ones, curatorial work that will also result in further suggestions of who you might like. Perhaps you spent some time on Facebook, organizing a photo album of your latest trip, or updating your cover photo to something cute and clever, an addition to your own digital exhibition of personal and cultural imagery. Perhaps, on Facebook, Twitter, LinkedIn, Google Chat, Google+, or a sex app like Grindr, Scruff or Tinder, you curated connections, making new ones, perhaps hunting by geographical location, and/or favouriting/deleting/blocking existing ones. Perhaps, finally, you unwound with Netflix, Hulu, Mubi or another film- and TV-watching service incorporating your every selection into further selections tailor-made for your tastes.

Some of you actually got paid to curate. If you work in fashion, you are probably curating in some way every day. As a model scout, you are looking for the next face, perhaps not even fully formed, but, as your eye and industry knowledge can tell you, eminently groomable. As a retail worker, you might arrange displays in addition to organizing racks and suggesting what works best for each client. If you work in a large department store, this job will go to a visual merchandiser – not just a window dresser anymore, for a visual merchandiser can function in all sorts of environments and, actually, very conceptually, and outside the fashion world. In fashion and other lifestyle industries, such as food, the role of the stylist has emerged as a prominent curationist profession. (A friend of mine in fashion recently told me, 'We didn't know we needed stylists until you could tell who *didn't* have one,' a smart comment on how curators spin wants into needs, becoming their own best value-imparters in order to seem indispensable.) Stylists, working in an editorial capacity, are, in true curatorial mode, collaborators, liaising with photographers, editors, designers and – especially if a celebrity is involved – the model or models, to determine which looks work best and are most

strategic for the season. (Another friend of mine who has done styling cleverly referred to these acts as ones of 'negotiation.') And this is just scraping the surface. In any lifestyle industry closely connected with media, you will find entire subsets of workers who are paid to activate their own cognition to select. Likely they are bringing their curated crops up through a hierarchy for ultimate approval, as evinced in the 2009 documentary *The September Issue*, in which *Vogue* editor-in-chief Anna Wintour is basically pictured in every scene pointing at things and saying 'yes' or 'no.'

If you work in digital, you are also getting paid to curate. Speaking of crops, perhaps the most common curator of our time is what has become known as the 'content farmer.' (Compare and contrast, figuratively, with writer Douglas Coupland's well-known coinages of the postmodern economy from *Generation X*, in which he referred to the office cubicle as the 'veal-fattening pen.') The content farmer is the dystopian new journalist, producing online content, typically for a large company, based on search data from engines like Google, in an attempt to garner more advertising revenue because of the popularity of the topic. Here, the value impartation is done by others (droves, really) via algorithms. Value is thus proportional to popularity, and audience courting is synonymous with it. There is no better example of the darkest, most tautological aspects of accelerated curationism: rather than the simulated democracy (or, at least, simulated beneficence) of curated works being presented as attractive to a potential audience because they have been chosen exclusively and carefully for their value, the value in these content-farmed works lies not in preciousness but in popularity. It is not a stretch to connect content farming to the increasing art-institutional interest in touring exhibitions. Revenue is scarce, so give the people what they want.

You may do something else in the fields of the cognitive or information economy, producing tweets for a large company,

for example, typically for little or no pay. As with the curatorial profession in the art world, digital-curatorial jobs tend to divide feudally, except the elite class in the digital realm is considerably larger and more entrepreneurial. These are often new types of designers. If you are a game designer, you are intimately involved in the curatorial act of audience courting, but you are also – as we saw with banks and other corporations – recruiting gamers as curators, asking them to manage their own experience, interactivity being an increasingly fundamental aspect of gaming. (Such recruitment is also instrumental to app design.) Experience designers are also a new and growing breed sprung from the curationist moment. Writing for the Australian website The Conversation, author, educator and qualitative researcher Faye Miller begins by pegging the following fill-in-the-blank phrase as 'the unofficial catch cry' of the twenty-first century: 'it's not just a _____, it's an experience.' Miller cites the concept of the 'experience economy' or 'exponomy,' which she traces back to a 1998 article by B. Joseph Pine II and James H. Gilmore in the *Harvard Business Review*, essentially contending that commodities have more impact when the consumer has an experience, one that is often collaborative and cross-platform. Miller uses the example of 'a major fashion event [that] would collaborate with the entertainment, media and tourism/hospitality industries to provide an audience with a lasting impression through a multi-sensory experience that is both enjoyable and prosperous.' To me, someone who deals with culture and its discourses rather than business, the description is redolent of biennials or large-scale conceptual-art projects in which curators are frequently instrumental. Miller, naturally, positions the late Steve Jobs as an incipient experience designer, quoting one of his many curationist quips: 'Creativity is just connecting things. When you ask creative people how they did something, they feel a little guilty because they didn't really do it, they just saw something.'

Gathering things, connecting them, sharing them with others in a way that positions one as a taste-making host: sounds fun, doesn't it? This is precisely why everyone is now doing it. Yet it is still not okay to call yourself a curator if you haven't somehow acquired that professional designation. In a dismissive 2013 posting on the art-and-design site Complex, independent curator Vanessa Castro lists 'people who definitely shouldn't have the title "curator" in their Twitter bios,' noting that 'the term "curator"…has been overused by many people so they can appear as "creative" types when in fact, they actually don't curate anything. Curators are supposed to be arbiters of taste, people who pick what's cool and trending in the world, people who have a trained eye for what is best. Most people on Twitter definitely don't fit this definition.' (One of Castro's more charming finds is @SusieBlackmon, 'Curator of news, information, & #horsebiz re Horses (Western, Thoroughbreds), Western Lifestyle, Western Wear, American West. Microblogger.')

I do not find Castro's objections convincing. I agree with her that the title of curator is itself inherently and inevitably curatorial, a way of imparting value to activities as exclusive and specialized work. But, as we have seen, what a curator is 'supposed to be' often leads to more interrogations than assertions. Castro's concerns speak to larger issues: first, to the ironic credentialist anxieties spawned by the cognitive or information economy, which still (as we saw with curatorial-studies programs) looks to old and arguably outdated models to legitimate what are plainly difficult-to-professionalize professions; second, to the old-fashioned way many people continue to understand their online curatorial activity and self-branding, hoping, eventually, to monetize it in a more traditional manner rather than doing it as a matter of course, for free. Such fantasies include a Tumblr turning into a best-selling book or a popular Twitter account leading to a position as a columnist.

Anxiety is one of the key drivers of the curatorial impulse in capitalist society and culture – an anxiety to ensure things are valuable and in turn to define them as somehow productive or useful. Søren Kierkegaard famously wrote, '[A]nxiety is the dizziness of freedom, which emerges when the spirit wants to posit the synthesis and freedom looks down into its own possibility, laying hold of finiteness to support itself.' Curation provides this finiteness. In a time in which information, population and ambition continue to accelerate unmanageably, there is an attendant desire to control, contain, organize and, as a result, make elaborate, fretful ontological claims. To reiterate Christov-Bakargiev's paraphrasing of Paolo Virno, 'You think you don't exist if you're not different from everybody else.'

If curators began to dominate the art world in the 1990s, they began to dominate everything else in the 2000s. This is the precise moment at which the avant-garde idea of culture failed, for throughout the twentieth century in the West, especially after World War II, we read experience aggressively through the Gregorian calendar, in a succession of vibrant, exciting decades: 'the 1950s,' 'the 1960s,' 'the 1970s,' etc. The 1990s, a perfect concluding paragraph to the avant-gardist twentieth century for introducing to the zeitgeist the concept of 'retro,' led to the bathetic non-apocalypse of Y2K, and then to the amorphous 2000s, in which most of our cultural innovations, most of what we could claim as completely and utterly 'new' in the avant-garde sense, came from the digital realm. Otherwise we were and are, to quote critic John Bentley Mays, living in '"the contemporary," [a] seemingly timeless zone of consumerism and spectacle,' a general and generalizing era in which, nonetheless, more people than ever before are clamouring for attention.

In the 2000s, digital innovations brought into culture an impulse very similar to the one that birthed the contemporary

curator in the 1960s and 1970s. Yet the masses of information parsed by upstart curators in the 2000s were not new but old. It was a nervous organizing and hoarding of data from the past that the internet made available in the present. Personal exercises of taste before the 2000s were a form of collector culture and often required pilgrimages and extravagant expense. These were not common activities. Two subcultures might be exemplary. Gay subcultures, which, with their devotion to histories not widely acknowledged and thus, in many senses, curated, sought out, for instance, rare 16mm prints or VHS tapes of Old Hollywood films, of opera-performance recordings, of fan ephemera of cult icons, etc. Audiophile subcultures dug through crates of records in numerous, vast record stores in cities across the world, crowing to friends about their latest finds, and using mail-order catalogues, conventions and auctions, anxious to possess something that might have taken years to acquire.

We all know what happened next: eBay, Napster, larger and cheaper bandwidth, faster download speeds, MySpace and Facebook as new methods of cultural display (supplanting the bookshelf or CD rack), the iPod and its iTunes – collection-assimilating entities that encouraged the hybrid, eclectic assortment of works into playlists, another banner word of the aughts that is betrothed to the verb *curate*. Many have written about the democracy afforded by such things. Lines drawn by the *Only Lovers Left Alive*–style vampire-snob curators of the Gen X 1990s, when you were either 'alternative' or 'hip-hop' but couldn't be both, were erased. Value is now imparted by what, at least on the surface, appears to be outré curation, and it is much more curation than what occurred in the 1990s, which might better be described as categorization. 'What kind of music do you like?' has become a tedious, unanswerable question. We hope our identities are more complex than that, and indeed desire them to be.

We have been schooled by the smarty-pants anti-snob snobbery of cultural-studies departments, which have taught us that anything is fair game for 'critical discourse,' from porn to the *Fast and the Furious* franchise. The advent of what has been deemed 'poptimism,' surely a concomitant of cultural studies, encouraged a critical appreciation of mainstream, hit-driven music that used to be dismissed outright by music snobs. Rather than initiating a cooling-off period, however, poptimism has merely abetted our curationist tendencies. It's not just what we like, but how we like it, a constellation of likes that, through social-media comments acting as didactic panels in an exhibition, paint what we hope is a complex picture. Follow our feeds for a few months and you might get a sense of our sensibility.

Shifting tastes and the end of snobbery are well-trod ground for cultural critics of the aughts. Less discussed is all the work that made these cultural texts, past and present, mainstream and obscure, available to everyone. This is largely anonymous work. It is also unpaid. But we count on it being done. Who uploaded the latest episode of your favourite television show to the torrent site you downloaded it from? Who uploaded the leaked track from the forthcoming album you've been so looking forward to hearing? More pertinent to this study: who sourced and assembled that blog of complete posters from your favourite commercial designer, or that perfect two-hour-long SoundCloud mix of vintage Chicago house that's your play-to-impress standby whenever you have guests over?

There are further links between unpaid digital curation and surveillance and outsourcing. Social-media sites now use your curatorial work as free market-research data. Big-data mining, including information on what you searched for and clicked on, is valuable capital, with Google, for instance, claiming it can track the spread of the flu virus based on

geographically specific word searches. The Essl Museum in Klosterneuburg, Austria, hosted the exhibition Like It in 2013, giving Facebook users access to images from their permanent collection and assembling a show based on what got the most likes. The Art Everywhere project, originating in the U.K. and now in American cities, asks people to vote online for their favourite institutional artwork, 'exhibiting' the winners on billboards. This is akin to publishers posting potential book covers on social media and making decisions influenced by what is most popular. It is outsourcing disguised as interactivity or 'engagement.' It also prompts the question: exactly how definitively curatorial can crowdsourcing be?

Such dangling carrots and their associated feelings of attention and connectivity suggest why people are so willing to do curatorial work for free. This work lends, in however compromised or superficial a form, significant degrees of agency to our lives. Value and work become aggressively conflated. Our music-listening programs basically ask us to be DJs, so why wouldn't we want to? Similar pro bono efforts happen in other areas of our lives in an appropriation of curationist professions. We are now travel agents, curating our trips based on discount airfare sites (there is no bargain more satisfying than one you feel you've uncovered yourself) and star ratings by users who've already been there. Nathan Blecharczyk, co-founder of the popular room-letting site Airbnb, told the *Telegraph* in late 2013 that they soon expect to overtake Hilton and Intercontinental to become the world's largest hotelier. Airbnb currently lists almost 500,000 properties internationally. All are vetted and guaranteed, yet so widely different in mood and client compatibility that traditional modernist hoteliers, with their pricey, anonymous, monolithic promises of hospitality, are struggling to compete.

Interior decorators and wedding planners are two other professions that, while still extant, seem increasingly obsolete.

They are very much professions of the 1980s, emergent cognitive-economy roles that were supplanted by more aggressive cultural gestures, such as Martha Stewart's in the 1990s and onward, which created an empire by empowering consumers to refine tastes while under her master watch. With the internet and its swaths of curated wedding photos, never mind instructional blogs, wedding planners have, like younger curators, become project managers rather than conceptualizers.

Witness the lavish wedding of Kim Kardashian and Kanye West at Florence's Forte di Belvedere in spring 2014. They had a high-priced wedding planner, Sharon Sacks, but one imagines she had little to do with the many putatively unwieldy touches, such as the made-at-the-last-minute Carrara-marble statues that fell apart, or the white bar West didn't like and manually disassembled, sawing it in half, or the expensive audio system West ordered to be dismantled, saying, according to the *New York Post*'s Page Six gossip site, 'You Italians don't understand my Minimalist style.' (West, who went to art school, is nothing if not an artist-curator, his whole career an aggressive angling in this direction; for Christmas 2013 he commissioned painter George Condo to paint a Birkin bag for Kardashian based on images from her Instagram account, uniting multiple aesthetics and personae into an object that, because of the unique conditions of its making, is essentially priceless.) The ostensible power afforded even by frivolous acts of curation is thus considerable. There is an argument to be made for the vehement movement behind marriage-equality rights in the last decade as being a fight for the right to curate: not only for access to the same legal exceptions and protections as straight couples, but also for the privilege to engage in the same bourgeois-curatorial rituals.

The popularity of reality television in the aughts spoke to something similar, particularly contest reality television like *Survivor*, *The Amazing Race*, *American Idol* and others, in which

a team of judges chooses runners-up and/or a winner, some-times granting viewers this choice, and/or the appearance of it through Twitter hashtags. The contestants themselves are trained in wily methods of curation, engaging in competitions demonstrating their abilities to throw existing materials together or to complete tasks under extreme time constraints, and present the results to judges as eminently valuable. (Shows like *America's Next Top Model* and its clever parody, *RuPaul's Drag Race*, as well as *Work of Art: The Next Great Artist* have all featured challenges involving trash or dumpster diving.) Furthermore, the environments of contest reality television are similar to those of parkour or *parcours*, conceptual obstacle courses used for physical and mental training of athletes, an idea that has been taken up by curators, for the *parcours* entails novel uses of the existing environment as a means of shifting viewpoints and physical orientations. (Parcours is actually the name of a programming initiative of the Art Basel art fair that involves curatorial interventions throughout the city of Basel.) Creating droves of mini- and micro-celebrities, high-period reality television also gave viewers the chance to debate winners and to choose favourites. With these shows' proliferation and seemingly endless brand extensions, there was a lot of work to do.

I do not intend to conclude on the *Matrix*ian bum note that choice is an illusion. Not entirely, at least. In that interview with Carolyn Christov-Bakargiev, she answered my Socratic question of how we can resist the programmatic choices proffered by curationism by saying, 'You become boring,' sounding like someone out of an Andy Warhol or William Klein film. 'You don't pick [because] it's all about choosing – selection, selection, selection.' So you refuse the act of choice? '[You refuse the act of] identifying a group of object or things within a *parcours*. That's why there's no concept [to Documenta 13]. It's just a mass of stuff.'

Christov-Bakargiev continues to work and refuse the title of 'curator.' In 2015, according to a press release, 'the 14th Istanbul Biennial…will be drafted by Carolyn Christov-Bakargiev with a number of alliances. She will seek the artistic advice of Cevdet Erek, the intellectual rigor of Griselda Pollock, the sensitivity of Pierre Huyghe, the curatorial imagination of Chus Martinez, the mindfulness of Marcos Lutyens, the acute gaze of Füsun Onur, the political philosophies of Anna Boghiguian, the youthful enthusiasm of Arlette Quynh-Anh Tran, the wise uncertainties of William Kentridge and manifold qualities and agencies to come as the process develops.'

Why is this so laughable? It is discursive and hedgy, introducing new diction ('drafted') for old concepts ('curated'). It is still curation, for it acts within an important art-world institution, the prestigious Istanbul Biennial, employing celebrity art-world figures (Pierre Huyghe and William Kentridge), and making superficial claims not to do what it is in fact doing, not to be what it in fact is.

I can hardly promise redemption for the contemporary art world. But I have firm conviction that its obsession with curating is coming to an end, however slowly. I have already outlined or implied as such. A précis: almost everyone in the art world has learned how to curate in the contemporary manner themselves. Artists still committed to relational or installation-based work want autonomy, no longer needing curators to advocate for them the way they did in the 1990s – although they do need curators to fill the unglamorous roles of project management, facilitation and advocacy. These roles, a cycling back to a much older mode of curating, will persist. A Szeemannesque curator, however, is no longer a value investment for an institution. A Szeemannesque curator may, in fact, be a liability. For what the exhibition-maker wants, given budgetary and institutional constraints, she so often cannot have: complete autonomy. The star curator's last gasp seems as a value

imparter at art fairs, although art fairs, market-driven beasts that they are, will no doubt dispose of the curator's auteur-imprimatur when it is prudent to do so. Currently, the art world seems to be drifting back to object-based making, with a return to modernist-formalist sculpture and painting, often to boring, empty effect. These are eminently salable objects that, for years, dealers have managed and presented with expertise. In this context, the exhibition maker is more or less superfluous, a dinosaur of the conceptualist era.

Artworks critiquing curationism, using curationism as the very means by which art is produced, are also emerging. London- and Berlin-based Tamil artist Christopher Kulendran Thomas's ongoing project, *When Platitudes Become Form* (its title obviously a poke at Szeemann), involves, in part, the purchasing of contemporary artworks from galleries in Colombo, Sri Lanka, in which a new contemporary art market has emerged as a result of the ending, in 2009, of a decades-long civil war against Tamils in the island's east and north sections. The superficial, salutary aspects of this – a liberalized, culture-oriented economy flowering from conflict – mask, of course, what many have called genocide. For an iteration of Platitudes at Toronto's Mercer Union, Thomas placed these contemporary artworks from Colombo throughout the gallery, reconfiguring them in a highly anonymous, white-cube fashion that divorced them entirely from their geographic and socio-economic contexts. For Thomas, contemporary art is Contem-porary Art, its anything-goes promises of plurality, with the curator in the role of Liberty Leading the People, hypocritical and shallow. In his exhibition brochure, Thomas told Georgina Jackson, Director of Exhibitions & Publications at Mercer Union:

[T]he trouble with Contemporary Art's 'equal aesthetic rights' is the same (at least structurally) as the trouble with the United Nations' assertion of universal human

rights. The liberal conception of universal rights upon which both are based allows Contemporary Art's cultural/historical remixing and justifies the toppling of certain dictatorships to hand down human rights but it prevents the addressing of internal structural oppression. It invokes an abstract idea of equality that is institutionally normalised without being able to see the means by which that normalisation occurs.

Meanwhile, at a former Unilever plant about 800 kilometres from Kinshasa in the Congolese jungle, artist Renzo Martens is, with a small team of people, establishing the Institute for Human Activities. Situated in what the organization's website calls 'one of the most disadvantaged regions of the world,' the IHA aims to institute a five-year 'Gentrification Program,' 'endeavor[ing] to make critical artistic reflection profitable for the poor.' As is typical of Martens' projects, the IHA functions as dark, uncomfortable satire. Yet it exists – its Unilever affiliation an ironic statement on corporate sponsorship in contemporary art, for Unilever sponsors a high-profile artist project at London's Tate Modern every year. The gist of IHA, then, is that curatorial projects, even when politically engaged, tend to funnel capital back to the West. 'At the locus of the actual artistic interventions in, say, Congo, Peru, or the Parisian banlieues,' reads the IHA's website, 'art may very well have an impact, though it often remains confined to the symbolic level. Such interventions rarely produce the material results achieved at the centers of reception... This gap is remarkably similar to the division between labor and profit in other globalized industries. Art may expose the need for change in Nigeria or Peru, but in the end it brings opportunity, improved living conditions, and real-estate value to Berlin-Mitte or the Lower East Side.' Martens and his team say they want to curate a viable economy in this area of Congo, using, again somewhat (but

only somewhat) satirically, *The Rise of the Creative Class* author Richard Florida's contention that the presence of figures like artists, writers, designers, etc., comes before the presence of companies, the provision of tax breaks, etc., in post-industrial economic development. In a video on the IHA's site, Florida is Skyped in to a Congolese audience, with Martens asking him questions mostly in earnest. The setting and juxtaposition are bizarre, with Florida onscreen in his impeccably decorated Toronto house, peering down at an audience whom he insists need to develop 'the three T's,' 'technology, talent, tolerance.' One audience member asks him how they can possibly develop talent in the creative-class sense, implying lack of privilege and resources, and Florida defaults to rhetoric, encouraging 'experimentation.' On their part, Martens and his team claim to want to begin an economy first by hosting those who are intervening and creating an industry around their presence, and then by instating creative workshops, in which the 'talented participants…will be challenged to develop their own artwork under the tutelage of professional artists.' (Canadians will note an uncanny resemblance to what James Archibald Houston did in Cape Dorset, Nunavut, in the mid-twentieth century, importing printmaking techniques from Japan in order to found studios to engage under-employed Inuit.) Whatever happens with Martens' project, it represents a fascinating mimicry of curationism, an aggressive attempt to make good on its critical and utopian promises. Its main success might be its actual funnelling of art-world monies to Congo, for it was initiated as part of the 7th Berlin Biennale and has a list of partners, including Eindhoven's Van Abbemuseum and the Amsterdam Fund for the Arts, that, while shorter, is not unlike Manifesta's. Call it curationist subterfuge.

Curationism outside the art world seems far from becoming obsolete. The curated experiences afforded by digital technology

are just too alluring and facilitating. 'My metaphor is always signal versus noise,' says Jesse Hirsh, Toronto-based broadcaster, researcher and self-described 'internet evangelist.' He suggests that, at its most useful, curated content provides us with guidance and clarity. Hirsh is critical, however, of the types of curation to which we subject ourselves online – ones that are, he notes, not new. 'If you define yourself through what you love, that's what consumerism always has been: buy shit to show who you are. On the internet you don't have to buy it, so it's easier, but it's still consumer identity as curation.'

In an echo of Jaron Lanier's popular, trenchant 2010 book *You Are Not a Gadget*, which contends that much of digital culture, because of the arbitrary way it was initially designed, has a way of flattening and thus frustrating user experience, Hirsh finds that huge social-media conglomerates like Facebook and Twitter actually generate very facile experiences based on antiquated modes of media engagement.

'It speaks to the failures of artificial intelligence and machine learning that it's still in such early, early days,' Hirsh says. 'It depends upon categorization, and the adjacent term of *folksonomy*, crowd-driven taxonomy – that's really how Google operates. Google wants to make it seem like it's the source of all wisdom. But all that Google is is an aggregation of people's taxonomy and curation. For the thirty years that the internet has not totally been academic and military, categories have been the means by which everything is governed. Most websites are still governed by categories. All the algorithms and software are still glorified categorization.

'You're not getting interesting aesthetics presented as thematic, navigational ways of exploring the web,' he continues. 'The surrealism of the web is still in short supply. It's a very literal, let's-put-everything-in-a-box approach. That lends us a logic on how we sort through things and a self-fulfilling dependence on algorithms. Rather than trying to find a better

way, Twitter, Facebook, they all just depend upon algorithms, thinking, in the case of Facebook, that we don't want to see all of our friends, just the friends they think we want to see. It's patronizing. It's a constant curation but it goes back to basic notions of identity: who we are is expressed by what we like and collect. And that logic is obviously the Facebook algorithm; it's the Google algorithm. What we click is what we like and is a constant collection or curation of taste and preference. And arguably, again on the machine-learning side, it's flawed. Because we don't always click for the same reasons. We don't always collect for the same reasons.'

Hirsh imagines a future in which 'curating becomes just this thing that people think they do because everyone does it. It's like breathing.' At the same time, he thinks 'there will always be a role for tastemakers. People who find obscure stuff that no one knows about and bring it to their friends' attention.' He mentions a performance context, in which people engage with the cultivated sharing of bits of online data and imagery – tweets, for instance – in a live setting, something he experimented with at the Toronto venue the Academy of the Impossible, a 'peer-to-peer lifelong learning facility.' 'It's not really curating,' he says. 'It's like curating, but that's not quite the right word.' Hirsh suggests that curating implies a force and a passivity; one party submits, the other dominates. His own fantasy of the end of curationism seems to be its deconstruction into something truly mutual.

While I was writing this book, several cultural phenomena emerged that appeared to express dissatisfaction with the power imbalances generated by curationism. One was the split of actor and lifestyle-curator Gwyneth Paltrow with her husband of eleven years, musician Chris Martin, and Paltrow's damage-control press release, published on her website GOOP, saying they would 'consciously uncouple' rather than divorce.

The phrase, suggesting a delicate, enlightened separating, perhaps with the aid of therapists and meditation, raised significant ire and mockery online. *Vice*'s Julie Mitchell wrote, 'they didn't get divorced like the middle class would… "Divorce" means fights in the kitchen and barbed comments over plastic glasses full of 2% milk.' Some things cannot be curated; breaking up, apparently, is one of them. This affirmation of untidiness, of dirtiness, this collective reaction against the notion that unsettled feelings themselves can be moored, even framed, seemed a reaction against curationism, which, as we have seen, aims to please, attract, deflect and euphemize. Curationism then seemed to me synonymous with repression, a sort of WASPy micromanaging of life that ignored impulse, passion, destruction and anger. It is perhaps apt to return to the stereotype of the art-world curator as suited and put-together, not a hair out of place.

At the same time, the internet was discussing something called 'normcore,' a style-cum-philosophy coined by K-Hole, a New York–based art collective (or, as they put it on their website, 'trend forecasting group'), that was picked up and discussed in *New York* magazine by writer Fiona Duncan, with the title 'Normcore: Fashion for Those Who Realize They're One in 7 Billion.' The article, inspired by one of K-Hole's several bleak, modernist-style manifestos available as downloadable PDFs on their site, explained the 'stylized blandness' that was apparently becoming rampant among the young and/or fashion-minded: ill-fitting, plain T-shirts, pants and other mass- and factory-produced clothing worn by, well, the not young and not fashion-minded. (As a friend of mine put it, 'Think Larry David.') The backlash against normcore was, yes, curationist in sentiment, seeming, at times, panicky in its refusal to believe that identity could lie outside sartorial statements of taste, like a goth-punk whining to her parents about her school's dress code. Weeks following, *Vogue* U.K. did an online

spread entitled 'Meet Norma Normcore,' which evidently involved a stylist, and seemed to defang normcore in one fell swoop. The very idea of normcore, as it had trickled into culture, seemed more of the same: young, sexy people can wear whatever they want and look distinct and alluring in it; the avant-garde was extant and this was its latest lob; the demystified had yet again been remystified.

K-Hole's own manifesto provided more provocative language, resounding Christov-Bakargiev's call to 'become boring.' 'If the rule is Think Different, being seen as normal is the scariest thing,' the manifesto reads, and then, something that could have come out of Wolfe's *The Painted Word*: '(It means being returned to your boring suburban roots, being turned back into a pumpkin exposed as unexceptional.)' (Compare with 'There is nothing more bourgeois than being afraid to look bourgeois,' a quote attributed to Andy Warhol and included in Wolfe's book.) Still, however, K-Hole see 'acting basic' as the next step in the avant-garde march of planned-obsolescence culture. 'Having mastered difference, the truly cool attempt to master sameness.'

Less absurd was Miya Tokumitsu's 'In the Name of Love' article in *Jacobin* magazine, which claimed that 'there's little doubt that "do what you love" (DWYL) is now the unofficial work mantra for our time. The problem is that it leads not to salvation, but to the devaluation of actual work, including the very work it pretends to elevate – and more importantly, the dehumanization of the vast majority of laborers.' Tokumitsu's argument rightly dwells on class as an enabler and realizer of the DWYL ethos, and laments the ways in which traditional work, which still has to be done, has been erased. Here, in the context of curationism, we are talking about two related things: the information and cognitive economies and their new subset of professions, but also, more crucially, the deeply problematic curationist view of work, which, as we have seen, elevates and

fetishizes deskilling and reskilling. As paradoxically agency-obsessed yet people-pleasing curationists, we have created a trap for ourselves, one reflected in the very professional conundrum that is the curator: more want to do it than can make a living doing it. Tokumitsu's further arguments are very much in line with my own. She notes, for instance, that 'DWYL reinforces exploitation even within the so-called lovable professions where off-the-clock, underpaid, or unpaid labor is the new norm: reporters required to do the work of their laid-off photographers, publicists expected to Pin and Tweet on weekends, the 46 percent of the workforce expected to check their work email on sick days. Nothing makes exploitation go down easier than convincing workers that they are doing what they love.'

At its worst, the power-mongering of curationism creates an intolerable noise, a constant cycle of grasping and display. To escape and conquer this, there must be stillness. Curationism is compulsive, attention-deficit. As we saw with Gioni's Venice Biennale and Obrist's collecting of interviews, it can take on the tone of the hoarder or the Orwellian archivist, with discrimination and fine-tuning falling away. The millennial curator wants this, that, everything, Christov-Bakargiev's tactic of not curating by presenting 'a mass of stuff' seeming, despite its protestations, akin. We hoard in our daily curatorial activity, the internet making so much available, and digital folders storing so much more than physical shelves, with their files, ephemeral and deletable, permitting complete lack of commitment. To possess is not to understand, and can produce boredom, entitlement and apathy. We are now all Charles Foster Kanes, our devices our Xanadu mansions, with half of our possessions under dust cloths. I write this book on a laptop nearly full with albums and films, half of which I've never listened to or watched.

My personal sanctuary is, ironically, the museum, where, increasingly, curatorial and institutional interventions prevent

quiet contemplation, compelling prescribed ways of looking and listening and encouraging superficial methods of engagement like smartphones and activity centres. There are lovely exceptions, of course. The Frick in New York, the Kunsthistorisches Museum in Vienna, the Gemäldegalerie in Berlin and that fantastical museum about museums, the Museum of Jurassic Technology in Los Angeles, are all oases divorced from the panicky exigencies of the contemporary market, out-of-time hallucinatory spaces encouraging lingering and exploration. It is naive, perhaps, to call for greater contemplation in the face of an economy and attendant culture centred on the bourgeois self and its predictable contexts. Yet I insist: you are more than what you like. You are more, even, than *how* you like.

But because curationism raised me too, I end with something I like. It's a poem on the cover of the debut album of U.K. post-punk band Savages that I read as I began this book. Its call-to-action is preferable to Christov-Bakargiev's 'become boring.' Curationism, it seems, has forgotten the very root of 'curator': *cura* or *care* and, by extension, genuine curiosity.

THE WORLD USED TO BE SILENT / NOW IT HAS TOO MANY VOICES / AND THE NOISE / IS A CONSTANT DISTRACTION / THEY MULTIPLY, INTENSIFY / THEY WILL DIVERT YOUR ATTENTION / TO WHAT'S CONVENIENT / AND FORGET TO TELL YOU / ABOUT YOURSELF / WE LIVE IN AN AGE OF MANY STIMULATIONS / IF YOU ARE FOCUSED / YOU ARE HARDER TO REACH / IF YOU ARE DISTRACTED / YOU ARE AVAILABLE / YOU ARE DISTRACTED / YOU ARE AVAILABLE / YOU WANT FLATTERY / ALWAYS LOOKING TO WHERE IT'S AT / YOU WANT TO TAKE PART IN EVERYTHING / AND EVERYTHING TO BE A PART OF YOU

/ YOUR HEAD IS SPINNING FAST / AT THE END OF YOUR SPINE / UNTIL YOU HAVE NO FACE AT ALL / AND YET / IF THE WORLD WOULD SHUT UP / EVEN FOR A WHILE / PERHAPS / WE WOULD START HEARING / THE DISTANT RHYTHM / OF AN ANGRY YOUNG TUNE – / AND RECOMPOSE OURSELVES / PERHAPS / HAVING DECON-STRUCTED EVERYTHING / WE SHOULD BE THINKING ABOUT / PUTTING EVERYTHING BACK TOGETHER / SILENCE YOURSELF.

Acknowledgements

Because the art world is sensitive and capricious, I am compelled to note that while the following names provided invaluable support, recommendations, interviews and inspiration, they do not necessarily share the views expressed herein.

Derek Aubichon, Hannelore Balzer, Marla Balzer, Ron Balzer, Daniel Baumann, François-Henry Bennahmias, Randi Bergman, Dallas Bugera, Andrew Burdeniuk, Bill Burns, Paul Butler, Carolyn Christov-Bakargiev, Alison Cooley, Noah Cowan, Catherine Dean, Shelley Dick, the Dorothy H. Hoover Library at the Ontario College of Art and Design University, Tess Edmonson, Lee Ferguson, Juan A. Gaitán, Daniel Gallay, Britt Gallpen, Aaron Goldsman, Sky Goodden, Frank Griggs, Sophie Hackett, Alden Hadwen, Sheila Heti, Dave Hickey, Jesse Hirsh, Andrew Hunter, Georgina Jackson, Andrea Janzen, the Japan Foundation, Mami Kataoka, Sholem Krishtalka, Michael Landy and the National Gallery in London (for a perfect cover image), Pamela M. Lee, Chandler Levack, Karen Love, Laurel MacMillan, Katherine Connor Martin, Rea McNamara, Patricia Mero, Kevin Naulls, Sean O'Neill, Maxwell Paparella at the Bard Center for Curatorial Studies, Darren Patrick, Andréa Picard, Elena Potter, Rosie Prata, Nava Rastegar, Kevin Ritchie, Elyse Rodgers, Stuart Ross, Nadja Sayej, Sarah Robayo Sheridan, David Shulman, Roberta Smith, Sarah Smith-Eivemark, Sasha Suda, Christopher Kulendran Thomas, Laura-Louise Tobin, Janet Werner, Amy Zion, the entire staff at *Canadian Art* magazine and the Canadian Art Foundation.

An exceptional thank-you to the amazing team at Coach House Books, particularly Alana Wilcox, who is unicorn-like in her commitment to writers, and especially to my editor, Jason McBride, who, despite his humble protestations, has done more for my career as a writer than anyone else.

About the Author

David Balzer has contributed to publications including *The Believer, Modern Painters,* Artforum.com and the *Globe and Mail,* and is the author of *Contrivances,* a short-fiction collection. He is currently Associate Editor at *Canadian Art* magazine. Balzer was born in Winnipeg and currently resides in Toronto, where he makes a living as a critic, editor and teacher.

About the
Exploded Views Series

Exploded Views is a series of probing, provocative essays that offer surprising perspectives on the most intriguing cultural issues and figures of our day. Longer than a typical magazine article but shorter than a full-length book, these are punchy salvos written by some of North America's most lyrical journalists and critics. Spanning a variety of forms and genres – history, biography, polemic, commentary – and published simultaneously in all digital formats and handsome, collectible print editions, this is literary reportage that at once investigates, illuminates and intervenes.

www.chbooks.com/explodedviews

Typeset in Goodchild Pro and Gibson Pro. Goodchild was designed by Nick Shinn in 2002 at his ShinnType foundry in Orangeville, Ontario. Shinn's design takes its inspiration from French printer Nicholas Jenson who, at the height of the Renaissance in Venice, used the basic Carolingian minuscule calligraphic hand and classic roman inscriptional capitals to arrive at a typeface that produced a clear and even texture that most literate Europeans could read. Shinn's design captures the calligraphic feel of Jensen's early types in a more refined digital format. Gibson was designed by Rod McDonald in honour of John Gibson FGDC (1928–2011), Rod's long-time friend and one of the founders of the Society of Graphic Designers of Canada. It was McDonald's intention to design a solid, contemporary and affordable sans serif face.

Printed at the old Coach House on bpNichol Lane in Toronto, Ontario, on Rolland Opaque Natural paper, which was manufactured, acid-free, in Saint-Jérôme, Quebec, from 50 percent recycled paper, and it was printed with vegetable-based ink on a 1965 Heidelberg KORD offset litho press. Its pages were folded on a Baumfolder, gathered by hand, bound on a Sulby Auto-Minabinda and trimmed on a Polar single-knife cutter.

Edited by Jason McBride
Copy edited by Stuart Ross
Designed by Alana Wilcox
Series cover design by Ingrid Paulson
Cover photo: Visitor operating Michael Landy's kinetic sculpture, *Saint Jerome* Photo © The National Gallery, London, with permission from Michael Landy and Thomas Dane Gallery
Author photo by Jim Verburg

Coach House Books
80 bpNichol Lane
Toronto ON M5S 3J4
Canada

416 979 2217
800 367 6360

mail@chbooks.com
www.chbooks.com